Learn to **See**, Learn to **Draw**

For my own pathway into drawing, with all its false starts and detours, I owe great thanks to:

» my wife Vlada and our two children, Naomi and Maxim, for their great patience, support, and just in general.

» a painting instructor in Homburg, Saarland when I was ten years old, who gave me a start in gestural drawing that is still tangible to this day – in only 15 minutes while I was waiting for my mother, who was late picking me up.

» the blank spaces in my textbooks, which I filled with abstract drawings throughout my school years.

» my art teacher in the 9th grade at Max Planck Secondary School in Heidenheim. When she saw a drawing I'd made in defiant boredom of a bottle standing around, she spontaneously decided to spare me from further 3D craft projects – with the words 'You need to do something like this.'

» Ms. Moser, the art teacher at the Secondary School for Science in Heidenheim, who first got me talking about composition and my previously unconscious aesthetic decisions, and through this caused me to reflect on 'seeing-thinking'. At the time, I didn't yet realize how important that was going to be.

» Mr. Kafka at the university in Wuppertal, who found my application portfolio lacking, but found my ideas very good. If he was just being polite, it was nevertheless encouraging.

» the commission that waved through my application portfolio for the design studies program, probably mostly out of kindness.

» Prof. Peter Wörfel at the Niederrhein University of Applied Sciences, who convincingly taught us about Bauhaus design theory.

» Prof. Manfred Vogel, ibid, who helped me to make my strokes more lively and powerful.

» the illustrator and author Wolf Erlbruch, whose promotional illustrations at TEAM/BBDO Dusseldorf in the late 1980s impressed me so deeply that something within me decided I would one day figure out how really good drawing works.

» Albrecht Rissler, who with his book Zeichnen in der Natur ('Drawing in Nature') showed me that even difficult things like bushes and trees can be drawn.

» Brian Bomeisler, who in several courses in New York taught me a great deal about what I lacked in achieving satisfaction in drawing, and who proved to me that sketching doesn't hurt at all.

» Betty Edwards and her first book, which I got my hands on by chance in about 1982. Unfortunately, I only did the first two exercises at that time. In 2012, thanks to a more recent edition of her book, I realized that I had missed a few things.

» Adolph Menzel, the incredible draughtsman of the 19th century, and his pencil drawings of everything there was to be seen.

» Kimon Nicolaïdes, the legendary teacher who taught at the Art Students League in New York until the late 1930s. His ideas and methods, published in the book The Natural Way to Draw (e.g. drawing from observation without looking at your paper), inspire many draughtsmen and drawing teachers to this day.

The very different drawing school for the talented, the untalented, the semi-talented, the stressed, and the outright desperate

Learn to See, Learn to Draw

The Definitive and Original Method for Picking Up Drawing Skills

David Köder

 HOAKI

'... in spite of everything I shall rise again: I will take up my pencil, which I have forsaken in my great discouragement, and I will go on with my drawing...'

Vincent van Gogh

'The supreme misfortune is when theory outstrips performance.'

Attributed to Leonardo da Vinci

Popcorn studies. Fineliner, washed. Beatrice, age 13.

Up until now, the level of 'good drawing' probably seemed so high that you rightly
thought of it as a wall. That's how it was with me, too. If you are open to a new approach, that can
change for you as well. A lot.
This book shows you – put simply – a ladder reaching upward. Uncovering and using it is up to you.

'It's not how good you draw, it´s how good you
want to draw.'

Loosely based on a quote by legendary English advertiser and
author Paul Arden

'What is the hardest thing of all?
That which seems easiest:
To see what is in front
of your eyes.'

J. W. von Goethe

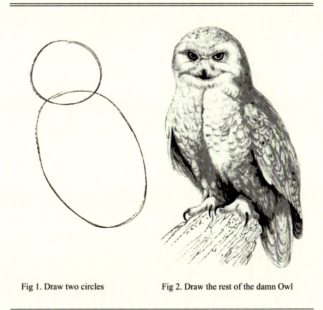

How to draw
an Owl.

"A fun and creative guide for beginners"

Fig 1. Draw two circles Fig 2. Draw the rest of the damn Owl

'Draw two circles.'

'Draw the rest of the damned owl.'

Know the feeling?
(Source unknown).

ΉHHHRG!!!

There's no more fitting way, in my experience, to sum up what most people go through with normal drawing books and lessons. Or what they went through as a child. I felt the same way, despite having studied drawing in university.

I received tips and technical instructions that didn't help much. I had professors who were brilliant at drawing. And a target level (self-inflicted) that seemed out of reach. In short: extreme frustration from the very beginning, since childhood. My parents gave me a 'paint-by-numbers' set when I was about nine years old. It had oil paints and a brilliantly illustrated eagle as a template. And instructions roughly like those here, with the owl. Of course, it had numbers instead of geometric shapes. Which was just as un-helpful. You can imagine what a mess came of it. And what a humiliating feeling remained while the oil paints slowly dried.

Pause – A Somewhat Different Table of Contents

Ummm... Drawing?
A Definition and What This Book Is Supposed to Do

Drawing is an infinite topic. Inner images, external images, no images at all – and everything in between. Strangely, drawing is something that's near and dear for most people early in life but later becomes something distant – often beginning, unfortunately, from the age of eight or ten.

Depending on one's viewpoint, drawing can be a universal language, the crowning discipline of the fine arts, a mechanical-realistic handicraft, material for aloof discourse, anachronistic, a preparatory step for painting, an unpleasant or even traumatic memory, drawing therapy, a presentation tool, or just something you do while you're on the phone. At least it used to be, until you started holding your phone in one hand and the steering wheel in the other.

What I mean by 'drawing' in this book is realistic drawing according to direct visual perception.

Everything else – conscious artistic work, developing an individual style, expressive and non-objective drawing, and applications such as illustration – is generally only possible on the basis of good perception and isn't what we're talking about here.

An Invitation to a Guided Voyage of Discovery

With this book, I would like to offer you a personalized and motivating invitation to the ABCs of perception and drawing. *L'Alphabet du Dessin* ('The ABCs of Drawing'), by the way, is the title of a book written by a certain Mr. Cassagne in the 19th century, with which van Gogh is known to have experienced an artistic breakthrough.

As we journey through this book, I'm 'only' providing you with the key to natural drawing ability. This ability seems to exist in every human being – but most are missing the key, unless they happen to have discovered it for themselves. Your goal at first is this: 'It's fun, it looks good, and it's not embarrassing (anymore).'

We begin with my specially designed, doable, and highly effective introductory exercises, which have absolutely no prerequisites – and by that I really do mean none, aside from the ability to see, some motivation, and the ability to hold a pencil. It's still important to read the instructions, however, and above all to do the simple exercises often, even if they seem too easy or perhaps pointless.

Later on, I offer additional practice drawings and share with you my experiences and insights through a large assortment of my own work. I would attribute some of these important insights to an approach to drawing which is still far too rarely taken seriously, in my opinion (and which is often completely misunderstood). To

my knowledge, Betty Edwards was the first to clearly articulate this approach back in the late 1970s. She presented it in her book *Drawing on the Right Side of the Brain®*, which deals with nothing other than truly 'learning to see', even for those who consider themselves 'untalented'.

Shortly after the publication of Edwards' book, Bert Dodson appeared with 'Keys to Drawing', which also aims to divide the learning process into doable individual steps, and which similarly mentions the right hemisphere of the brain.

Nowadays we see 'mindfulness,' 'perspective shift,' 'two different kinds of awareness,' and 'two different systems of thought' (Daniel Kahnemann) being discussed in many different domains – even reaching to those widely practised exercises in schools, aiming at the 'bilateral integration' of the two brain hemispheres ('lying 8' and

'Before' hand, adult course participant. Most of us draw at the same level at which we gave up in childhood.

Do you get peculiarly restless and impatient while drawing? How would you answer if I asked whether you truthfully felt

rather angry

inside?

Some people just burst out laughing. Whatever your answer, the stress of drawing has plagued me since childhood. I would like to share with you various approaches to drawing (and learning in general) that have changed things a great deal for me.

If as a child you lost touch with drawing and the fun that comes from it, it's not your fault. And it's not even the fault of your teachers.

the like). In the late 1970s, Betty Edwards's book was groundbreaking in that regard, and even today I find it timely and helpful.

Criticism of Edwards' suggested learning techniques generally falls along the lines of 'observational drawing is uncreative' or 'it's basically rote learning.' Interestingly enough, most of this criticism comes from people who cannot draw realistically, but who associate drawing and painting with strong emotions. For me, it was also quite a struggle to get started with (seemingly) uncreative practice drawings. As soon as my drawings started to become more realistic, however, I certainly didn't feel restricted or uncreative anymore. Quite the opposite.

Drawing teachers have probably been talking about 'learning to see' for many centuries. The keys to this were taken to be talent and extreme practise. Betty Edwards, as I see it, brought that view scientifically and funda-

mentally into question – quite fortunately, for those who wish to learn. She thought differently, suggesting new approaches to the old problem of teaching the 'untalented' to draw.

For me personally, her insights and ideas about learning were an important part of the puzzle of my own process of learning to draw. What I previously had been able to do in terms of drawing now began to coalesce, and above all, I now knew what I needed to be 'working' at, instead of just 'casting a line' with each drawing attempt and hoping that one day, just maybe my drawing talent would bite.

In this very visual book, I show you the way I learned. You can follow along step by step, becoming acquainted with new ways to see, and can experience for yourself the kinds of thinking and doing that can lead to progress.

You can use this book to get started 'thinking differently about

drawing' because it's designed and written completely differently from the conventional 'how to draw such-and-such' workbooks, in which all the pages are nicely uniform.

If you just have fun looking at the drawings, without any artistic ambitions, then I'm happy too. If while reading, however, a strangely wistful feeling creeps up on you – that could very well be your need to draw, perhaps suppressed at a young age. If the feeling comes up repeatedly, run a few times through the exercise where you re-create a single line – it can be done without any drawing stress, because it's not yet a 'proper' drawing. While doing this, it may happen that, for the first time in your life, you feel that 'other' feeling while drawing – the awakened visual awareness that is (among other things) the subject of this book.

It would be consistent with feedback that I received regarding

the first edition of this book. The present 2nd edition remains true to this approach and offers little that's new for those who are already familiar with the book.

I naturally don't promote a specific style of drawing or a certain technique beyond the learning stage. I am, however, now deeply rooted in the tradition which seeks a start in drawing through conscious visual perception.

Common Concerns and Legitimate Questions

I can't draw and have no talent. I'm certain I can't learn this.

That's understandable. The only thing that helps here is to experience your own, previously unactivated ability, which shows itself only through proper guidance and the initially very simple exercises. That is, with real learning instead of 'having a go to see if you're already good at it.'

I'm not creative at all.

Many people think they aren't creative. Often they say that because they can't draw. This is probably one of the reasons why success at drawing so often imparts creative self-esteem and can also open other doors in the mind.

I've already bought many drawing books. None of them work for me.

Trust me – it's not just you, or that you didn't practise enough. Use this book as a key to learning and find your gateway. Then look beyond at things that interest you.

I'm shooting for a creative career, but draw too poorly.

If good drawing is required, learn it. Full stop. In this book, I don't show you every key to good drawing that I know, only the best ones.

Will this book help me with preparing my portfolio?

If drawings are required or if you want to try submitting a portfolio, this book can help you see what you need to work on. Common themes: proportions, contrast range, liveliness, and overall effect. Getting into the flow of 'seeing-drawing' will usually help with generating new ideas for a portfolio. Good to know: lively, realistic drawing plus original ideas of your own are usually equated with talent.

I've attended several painting and drawing classes, but I can't seem to get going the way I would like.

Then I admire your determination and say to you that with the approach in this book, you have a real chance if you get stuck in. Understand and experience the real basics, then you'll be able to see some success again rather than continuing to fail.

Can you reach a high level if you didn't start early?

I ask myself the same thing. I didn't really start drawing by perception until 2012. Of course, some things were easier for me than for a complete beginner. Please note, however, that in my youth and in my studies I got a lot of practice at failing. I suffered a great deal from stagnation. So if you want to get started, stop complaining about a lack of talent, get going, and see what happens.

I want to be able to draw faces. Is this the right place for me?

Yes. But that's a bit like going to a driving school and saying, 'I want to learn to do right-hand turns.' In my view, it's like this: those who understand the basics can (learn to) draw anything. Anyone who starts with faces will have a hard time and will take much longer, if it works out at all. And what do you do if a left turn comes up?

Drawing is spontaneous. It's not something you can learn.

That's how it seems to many people. It used to be that way for me, too. And we tend to put talent ahead of everything else. I consider that a serious mistake. Once you realize what makes accurate drawing possible, you can learn it.

Why should I believe you?

Don't believe me, just believe in yourself. But please also believe in your new discoveries with this book, not your previous experiences and preconceptions. Make a new start. It's your future with drawing.

I admit, there are times when I was about to give up myself. Small successes with doable exercises helped me to persevere.

If that spontaneous childlike creativity seems lost, the artistic self-confidence that we see in small children can help you get it back. Most children also need about 9 years of success with realistic drawing.

How old should you be to get started with this book?

As an inspiration for learning, certain parts of this book are useful for children starting from 8 to 10 years old. My observation is that the inner critic can only be appeased through credible (even if small) successes, not through praise for drawings that in no way meet the child's expectations. This is one possibility for obtaining and building upon the artistic self-confidence of early childhood. From about age 15, everything presented here tends to be achievable, whereas I can only recommend the introductory exercises for children ages 8-10.

Realistic observational drawing kills creativity, what good is that?

I'm sure you think that way because you've had corresponding experiences. I did too, by the way. Those who actually do learn to draw according to their own perception usually experience it as a feeling of happiness. Also, how come we don't believe that it makes us musically uncreative to begin playing by following notes?

Realistic drawing is not mechanical copying – it's 'lively seeing', at least once you've learned how to see. Before this happens, the attempt can give you a very nice headache.

I'm looking for tips and tricks for drawing. Can I find them here?

Yes, you can. If you leaf around in this book you'll notice a lot of things which can be tremendously helpful with various questions about drawing. As an advanced learner, you can do a kind of targeted check of the basics, if you find that useful.

Pen follows eye. Seriously: if I can learn that, so can you.

This book is a giant mess, how can anyone learn something from it?

Don't let it get to you. What seems like chaos is actually a deliberate method of easing the switch to seeing-thinking. It may help to first leaf through the book and read the large headings to better recognize the overall structure – it certainly is there.

Caution: Once it starts to work, drawing can be quite addictive.

Please read this text without rotating the book.

Columbus sought the sea route to China. He found America by mistake. Even when you're looking for one thing, you may also find something else. By mistake. That's called 'serendipity'. In German, we might say 'Kolumbusität'. It's often the things we discover seemingly by mistake that have the most value to us. That's why it's good to keep leafing through this book. Who knows what little gems you may suddenly pick up.

Foreword

Unbelievable, but true: Lively, realistic drawing seems to be learnable. If, that is, you don't leave it to chance – to so-called 'talent'. That whole thing, by the way, about genius and talent was invented by the painters in the Renaissance, probably after they had discovered how they could learn to see a great deal more clearly and paint more realistically by using tools (mostly projections for consistent proportions). Which must've basically blown away their contemporaries. And which still baffles some art historians today. A key book on this topic is David Hockney's *Secret Knowledge: Rediscovering the Lost Techniques of the Old Masters*.

Why am I so sure that drawing has less to do with talent than people tend to think it does? First hand experience, both my own and that of others. So quit asking yourself if you're talented or not, and above all don't compare yourself with others at first. Just follow the steps and be amazed at how you, compared to you, are learning. Then you can start looking beyond.

David Köder

This book is your opportunity to experience how in drawing, as with other things, it's the parts that make a whole.

r

vo

Einstein's definition of insanity: 'doing the same thing over and over again and expecting a different result.'
This brings to mind the disastrous 'practicing'
I experienced in conventional drawing lessons.

This looks like meaningless lines, right? On the one hand, yes. On the other hand, this is more or less what it looks like when you train hand-eye coordination (the prerequisite for 'learning to see') in its pure form. More on that later. My recommendation is to forget for the moment everything you know about learning to draw and to allow yourself, as an experiment, to see and to learn in a new way.

Use learning aids as intensively as possible. In doing so, you'll be on your way to doing without them more quickly.

Hiding is pointless – your talent will find you.

This Book Is Useful...

... to you.
You don't have to fall into one of these categories. You can also just leaf through and look wherever your curious eyes lead you. The contents and design of this book have been lovingly crafted to enable you to use it in either a methodical or a random way. Just keep picking it up and having a look. Until it grabs you and you start to do something.

... to the stressed.
At the touch of a button, slow down and calm your mind: who wouldn't want that? Trends like Zentangle and colouring books for adults are signs of our times. With that kind of 'drawing' you can quickly reach a state of relaxation. If you want to go beyond colouring books, the way forward is here in this book. You'll soon be able to experience 'real' drawing, stress-free, and in the process will learn to draw with amazing accuracy – your own drawings.

... to parents.
Every child past a certain age would love to be able to draw well. If only they could. My experience coincides with the literature on the subject: Most people give up at about 12 years of age, when their 'inner critic' speaks up loud and clear saying: 'That doesn't look good' (in the sense of 'real', as the children will say when asked). Parents and art teachers can tell a child a thousand times: 'Don't worry, it's expressive and creative'. Yet the child will remain dissatisfied and will doubt his talent. Logically so. Because he or she was able to learn how to write, do math, swim, and ride a bike. But

I admit that even this book will benefit you only if you start looking and reading and let yourself have your own first little practical success stories.

when it comes to drawing, it subjectively seems impossible.

... to the uncreative.
All right, so you're not creative. That's okay. How, by the way, did you come to feel that way? Were there others in your school who could draw better than you? Was art class not

your thing? Or maybe it was, and now you have a job where creativity would get in the way? No matter. Go for a stroll through the book. Do a few of the exercises, they don't require any talent to complete. I promise: it doesn't take one spark of creativity to get started with clearer perception and drawing. Hard to believe, but true.

... to the creative.
For those that need creativity for their work, drawing (or learning to do so) can be one way to switch into turbo mode. It frees your mind, it can give you ideas, and it can help you relax. Even if you don't need drawing itself in your profession.

... to the untalented.
Good news or bad news, depending on your take: drawing has little or nothing to do with aptitude. Only with the approach to learning. This sounds absurd at first, but it shows up again and again and again in practice. The importance of aptitude is grossly overstated, while that of in-depth learning, in doable steps, is extremely underestimated.

... to the gifted and semi-gifted.
Those who heard frequently as children that they were talented at drawing often quit in frustration anyway (the 'Talent Trap Effect'). If that happened to you and the time has come to finish what you started, you're at the right place. This time, be proud of how you're learning, not of how 'good you are'. This time, have fun.

Drawing... do you really want to learn? Then welcome to the instruction manual that will help you awaken your personal drawing talent.

... to art teachers who can't draw well.

Depending on the school level and region, this happens – it's no secret. If you've found this book and are now reading it, props to you. That's a start – read on and discover a totally different side of drawing. Try it out and see for yourself. If you like, you can use some of what you find in this book 1:1, or as appropriate, in your lessons at school. With it, you'll be able to greatly enhance the creative self-confidence and interest of the children – fertile ground for the goals of aesthetic education, I'd say.

... to art teachers who can draw well.

So you can already do it. Wonderful. Maybe even since childhood, that happens sometimes. May I ask: how many of the people in your classes learn to draw really accurately? How many find an inner connection to the artistic that is sustainable and can be built upon? If you ask yourself the same thing and are looking for ideas regarding exercises that can be done with simple drawing instruments, you'll find practical suggestions and approaches in this book.

... to young people.

For me it's like this: I'd like a chance to talk to my younger self, at your age, from my present vantage point. If you have the urge to draw, make something of it. Learn it thoroughly. Do more than just a few cool drawings and introductory exercises, like I did at 17. Get deep into the basics, learn how to see. Get support if you get stuck. Set high goals, look for great role models. And be nice to yourself along the way.

... to adult colouring book enthusiasts.

If you're having fun with drawing again, or for the first time, wonderful! If, beyond the relaxed colouring book feeling, you want to see results that look like those of a 'talented' artist, then you're at the right place. 'Talent' has been decoded for a long time now and can be learned, as far as drawing goes, in relaxed individual steps. Take a stroll through the book, with your mind and your eyes. Some of the exercises come across as childishly simple – don't be put off.

The art of learning instead of 'learning art'

For me, this motto gets to the root of learning, perception, and the basics of drawing. I like achievability, not mystification. Of course, others see it quite differently, for a variety of reasons.

'In books and in life you'll deal with me often. I am doubt and self-doubt, the voice of reason, the imp of sabotage... call me what you will.'

A-MAZE-ING!

Random find on the Internet: a shortcut. Is there also something like this in the labyrinth of learning to draw? Even with this book, the path to drawing isn't so simple. And yet, if you accept the working hypothesis that drawing is a complex skill that can be learned in individual components, then doors can open in surprising places, where previously you saw only concrete walls. Heck, it even feels as if you can take shortcuts by walking through walls. But... you have to get started, otherwise all of this remains lifeless, empty talk.

Experiences, 'Aha!' Moments, Results

Learning to draw began to work for me when some crucial 'aha!' experiences led to real results. It would appear that advances in drawing occur in 'leaps of insight'. I was extremely relieved – finally, no more of the stressful and pointless 'practice'.

Real and comprehensible learning was new to me and it led to predominantly positive emotions in drawing. And to corresponding results. See for yourself.

You will, for example, read about five so-called component skills of the larger skill of drawing. The credit for being the first to divide the skill of drawing into these doable 'chunks' is owed, in my opinion, to the American artist and drawing teacher Betty Edwards. If you, too, want to understand and experience effective learning, you may find it useful to familiarize yourself with some of her insights (even briefly in theory) before getting started.

Vilnius, Lithuania: A sign in the train station indicating the stairs leading to the train to Moscow. It could just as easily be showing how peak performance is achieved: gradually.

'That's only five meters. Who wants to try it and see if he has enough talent?'.

Learning by Doing? Yes and No

John Wooden, probably the most successful basketball coach in the US, once said, 'Never mistake activity for achievment.' The nice-sounding approach 'learning by doing' comes with some nasty pitfalls. Of course, you cannot learn to draw without 'doing'. Unfortunately, however, 'learning' does not happen by itself when 'doing' complex activities.

Think of it in terms of playing the piano. Learning by doing would mean sitting at a piano for the first time, full of hope, without a teacher, and without any guidance. But with very high expectations. And lots of creativity. Have fun!

You can be more successful in learning with the cycle 'understand, learn, train (practise)' – not the other way around. If you 'practise' something misleading or confusing, the brain reliably learns the wrong thing. Including the corresponding emotions. For example, that you can't really draw. When this happens in childhood, it can become a fixed part of your worldview, a personal truth.

If you're looking at and reading this book, you probably still have a spark of hope. Quite rightly, by the way. When you understand that you, too, can look at things 'differently', then 'different' (and realistic) drawing will follow – sooner than you now believe.

On the one hand, on the other hand: A snapshot with an iPhone. Poor lighting, blurred image – and yet you probably spotted the dinosaur head in the route map of the Zurich S-Bahn on the left.

Seeing What You Haven't Seen Before?
A Small But Typical 'Aha!'-Moment.

On the one hand, this is a route map of the railway network in the canton of Zurich. On the other hand, it's also – with some imagination – a dinosaur head. Complete with mouth, teeth, and two eyes. Or with Lake Zurich and two other small lakes, depending on your perspective.

So far, I haven't met anyone in Zurich who could see the dinosaur before I pointed it out. People who draw seem to see things like this much more often than those who don't. From now on you'll always be able to see it, if you happen to be taking the S-Bahn in Zurich. This map of the night routes in Zurich is posted at every station and in every train.

19

When You Don't Score a Goal, the Problem Is Seldom Your Cleats – Keep It Simple

The good old soft pencil is an unbeatable learning tool. As is the eraser.

Why such soft pencils? With hard pencils, it's difficult to reproduce what I see on the paper. The stroke they produce is too light. They're better suited for technical drawings. I sometimes use them for finishing touches, up to 4H. The scale goes from 9B (the softest) to 9H (very hard). The Prismacolor Ebony pencil is apparently even softer than 9B (there are no universal standards here).

The leads of pencils are of course not made of lead, but mainly from clay and graphite. To go deeper into this subject, read *The Pencil* by Henry Petroski, 412 pages long – if you read all the way through this on your vacation, I guarantee you'll never get to drawing.

Find simple materials that are accessible and that don't get in the way of learning. Perception is complex enough already. Drawing is an adventure. Here on the right

are the materials that I mostly use. They were good enough for almost all of the drawings in this book.

Aside from the pencil, the thing that worked best for me, after an eternal search, was the Pilot Fineliner. The only exotic product I use is the 'Prismacolor Ebony' graphite pencil from the USA, basically a pencil with a thick lead that's so soft that you can almost 'paint' black and white with it, but which still works for detailed drawing. Any 6B to 9B pencil will work, however.

Find similarly simple materials for yourself. Then get started. Almost all of the drawings in this book were made on a DINA-A5* or DIN-A4* spiral-bound drawing pad from Boesner, 170 grams, and on Strathmore® 'Series 400' paper (for graphite-primed drawings). Be sure to test it, as properties can change (e.g. the paper's

absorbency). Any heavy-duty white or slightly off-white paper with 'medium' surface texture will work, however. This means it isn't quite smooth (as is used for true pen drawings), but also isn't especially rough.

You can find good quality drawing pads in art supply stores, including large chains with online shops such as boesner.com and

gerstaecker.de, but also, of course, in local specialized shops. Often these will have test pads available to try out.

** Half letter size (5 1/2 x 8 inches)*

** American letter-size paper (8 1/2 x 11 inches)*

These items are more than enough for an uncomplicated starting point.

My cabinets used to be full of materials and my drawing pads were almost empty. Know the feeling?

◄

Eraser and kneaded eraser

Sharpener and art knife

Water brush

Pilot Fineliner, water-soluble

Prismacolor Ebony pencil, very soft

Starbucks coffee stirrers, for sighting

Pencil cap eraser, rather soft

6B Pencil

4B or 6B graphite sticks (not shown)

Watercolor brush for 50 euros, drawn with a soft pencil for 80 cents. A similar ratio exists between the difficulty level of the associated techniques (depending on your expectations, of course).

With graphite (pencil) and erasers you can do (and learn and practise!) almost anything, except colour.

Having a go with the Pilot-Fineliner. Use the water brush to dissolve the lines (and shapes) on one side (this is called 'washing'). Off to one side, you can see tests for generating gray values, with washing and without. After a few failed attempts I got it right.

Typical flooding when first starting out. Way less water! The brush only needs to be damp.

It works best with very little water, when the brush is only slightly damp. To get rid of some water, you can dab it or brush it on the back of your hand.

You can also test out and become familiar with washing using simple shapes like these.

Brush from the inside or dissolve from the outside. Ideal for getting to know the water brush.

You don't yet need to be able to do what you see here. Nor do you have to learn it immediately. I want to show you in advance, for motivation, a technique which I had a great deal of fun with <u>after</u> I'd finished my basic training. If my fineliner drawings toward the back of the book appeal to you, it's probably due to this technique – but even more so to the relatively consistent proportions.

There from the Beginning: Fineliner and Water Brush, Two Amazing Companions for Learning to See and Sketch

I'm showing you this as a preview, because it made it so much easier for me to get started with sketching. I started small and went up from there – but I found washing with the water brush helpful right from the beginning. Due to the tonal values, the effect changes immediately and the drawings gain more substance. Here are a few ideas for mini-exercises in getting to know the water brush, as well as examples of applications in drawing.

You can do a lot with just the inexpensive fineliner – here, in the water-soluble variant (it works well with the Pilot-Fineliner, for example) I recommend investing a few sheets of paper to become familiar with these materials. (For 'real' drawings, I'd wait until you've done the introductory exercises here in the book).

A brush with water in the handle quickly creates tonal values by dissolving ink in a targeted way. Be careful when dispensing the water – for me it works best if the brush tip is dabbed on a cloth or your hand and is damp instead of wet when it first touches the paper. Did you notice that the small circle with gray around it looks a bit lighter than the paper? I copied that from old Japanese ink drawings.

Whether you like fennel or not, it's very useful when training with washing.

Statues at the Metropolitan Museum of Art (MET) in New York. Only attempt things like this later on, when you are getting well along with proportions.

If after your basic training you try your hand at sketching people, the water brush will serve you well. All subjects quickly gain more substance using this method.

'Freedom is the recognition of necessity.'

Friedrich Hegel

And certainly much more than that. But as far as the basics
of perception are concerned, I'm confident that's true – other-
wise, learning to draw would remain a coincidence.

There is also analytical drawing, non-objective drawing, technical draw-
ing, scientific drawing, manga drawing, academic drawing, and more.
I can show you something about drawing according to perception – for
many, this is still or is once again the supreme discipline of the fine arts.

'Let us now come to the reasons for suffering. The main
reason is ignorance.'

Buddhist geshe Michael Roach (paraphrased).

Nobody has ever learned to draw through knowledge alone. However,
due to the prevailing ignorance on how drawing can remain accessible
beyond the age of about 12 years, generations of children do not learn
to draw. Because of this, they also tend to give up much of their creative
self-confidence. This means that companies later have to undertake
elaborate creativity seminars to help their employees come up with
more ideas.

You're well aware of what a potato is. But have you ever really looked at one? The famous painter Henri Matisse once said: 'When I eat a tomato I look at it the way anyone else would. But when I paint a tomato, then I see it differently.'

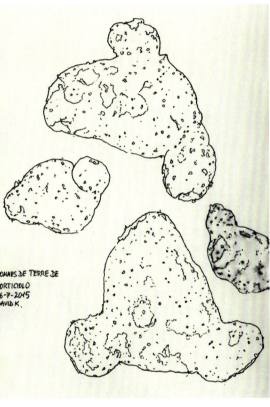

POMMES DE TERRE DE
PORTICIOLO
26-7-2015
DAVID K.

Sundae and local potatoes
From the Corsica Sketchbook, 2015.

Confidence in your own (sometimes buried) creativity can flourish when you are successful with accurate, lively drawing.

'We cannot solve our problems with the same thinking we used when we created them.'

Attributed to Albert Einstein

A classic. On this, everyone agrees. But first you have to be aware of fundamentally different ways of thinking (e.g. seeing-thinking and speaking-thinking).

Talent Is the River – and You Can Learn to Swim

If you want, you can also think of this book as a 'drawing course for non-swimmers'. You don't need talent. You do need curiosity and courage. And you must – metaphorically speaking – learn to flip a switch in your head. Fortunately, the prospects of learning are much more promising when you switch to 'seeing-thinking' than when you simply practise for years and hope for progress.

The Thing About Talent, Ego, and High Expectations

While at home on a Sunday in the summer of 2012, I picked up a dusty book. As I was leafing through it, I remembered a few long-forgotten exercises that I'd found strangely fun when I was 17. And here they were again, those peculiarly impressive drawings.

There was no denying that, despite having completed a degree in design studies, I hadn't experienced a real breakthrough as a draughtsman to the level that I'd wished for. I drew even worse than the creators of some of the example pictures in that old book. And those were supposedly beginners after a mere five days of instruction.

What if I'd put the book down too early? What if I'd never lacked talent, because talent plays no role in drawing? Determined, I acquired a current edition and the learning materials that went with it.

This branch in a glass took me hours. But I didn't find it as bad as I had feared. Against all reason and experience (I had proved to myself for years by many failures that I couldn't really draw and that I was relatively untalented), I took hope.

Starting with the basics was hard on my ego, because after all, I had studied design and even completed a master's degree in it. The exercises were sometimes so minimalist, or at first glance so boring or absurd, that I began to doubt. But in doing them, things started working. With amazing results and a feeling of satisfaction. It was a completely new feeling in drawing.

No longer the usual 'let's see what I can do', but instead understanding and learning, step-by-step. And only then practising. Some of it worked, some not so much. Some I didn't dare try at

all. But now I wanted to learn. And I found it liberating that I was allowed to draw with the eraser.

I found out where Betty Edwards' son teaches, the author who in 1978 had written the amazing and constantly updated book *Drawing on the Right Side of the Brain*®*. His name is Brian Bomeisler, an artist who at that time was living in New York and teaching courses in the United States. Betty Edwards herself had studied art and later earned a PhD in art education and perceptual psychology, a pretty rare mixture. She is, in the eyes of many in the US, the most successful drawing teacher in the world. By her own statement, she teaches novices. To put it plainly: untalented

* Meaning 'using the right side of the brain for drawing', with the convenient double meaning of 'drawing on'.

beginners. Ouch. It wasn't easy, at first, for me to associate myself with that.

HANDS

CHAIR

CUP →

Drawing symbols ('<u>What</u> is it?').

How would you describe the differences between the small drawings in these two images?

For me, it's not about 'good' or 'bad'. They're simply two completely different ways to draw. The one below looks to me more like seeing and observing, somehow more real. Here to the left, it's more like generic symbols. Do you recognize these two fundamentally different ways of drawing?

Drawing visually ('<u>How</u> does it look?').

One of my first attempts in 2012. It made me curious for more.

'Bla bla bla. Nobody's reading this anyway. Show me instead how to do manga. Or abstract flowers in acrylic.'

Trick No. 1: At the Beginning, Compare Yourself... Only With Yourself

That's the best way to keep track of how you're progressing.

I got over my hangups and after three weeks of classes in New York with Brian Bomeisler, Betty Edwards's son, I was very surprised. I had indeed been missing some basics, which then helped me to continue to develop as an artist.

For example, if proportions aren't quite right because you lack a good method of feedback, a drawing will always remain unsatisfactory. That was one of the problems I'd had.

Since 2013, I've been giving German-language courses on the basics in drawing myself, whenever I get the chance. Because it's just too enjoyable not to do so.

Please use the examples from these courses as a motivation and indication that drawing really can be learned – once you finally discover that it's possible.

As an effective way of easing you into things, I'll show you additional basic exercises that I've developed. And as a further little nudge, you'll be able to see many of my drawings right from the beginning.

Especially combined with the water brush, it's easy to create interesting drawings and sketches with a simple fineliner. I'll show you that, too. Many of the examples you'll see are in soft pencil and eraser on graphite-primed paper. This is like drawing on medium-gray paper with light and dark pens (a technique that has been known for centuries), except that you instead use graphite primer, eraser, and pencil. Using this method, you can really get things rolling with perception, because you don't have to battle with drawing techniques as much.

We've all heard the old saying, 'Make haste slowly'. Prior to my

If you take your time in learning, your talent will catch up faster.

experience of really learning to draw, I took this adage to be nonsense. Now I say that whoever came up with this idea was right, as far as drawing is concerned, though to make things clearer in this context I might instead say 'When in a hurry, slow your pace'.

I learned the most when I was able to understand how people think when drawing, as well as where their perception is directed. When this happened, technique seemed to be merely a transcription of perception: a kind of shorthand or simplification. You rarely draw everything, after all. It's about a good illusion. The test is if it feels right when you look at it. And if most other people like it too.

Practice like the masters instead of 'practice makes the master'.
That makes all the difference.

Small steps and conscious, slow learning with feedback are crucial. This is the fastest way to reach your drawing goals.

Identify as clearly as possible what exactly you want to be able to do. At first, even adaptation and copying are helpful. This is all the more true when they involve drawing styles and rhythms that you find interesting. You'll need to distinguish <u>at first</u> between originality/ creativity and the conscious development of your drawing possibilities. And keep learning the basics until they become automatic!

Put very simply, because you can learn to 'switch' over to the artist's eye, there's no talent needed for drawing. In other words, if you use the switch, you'll soon tend to draw as if you were talented.

»I WILL GRANT YOU ONE WISH.«

»I WANT TO BE PICASSO.«

07-12-2015
DAVID KODER

I used to think that exciting subjects were needed for drawing. Now I think that almost everything can be drawn in an exciting way; this happens automatically when you learn to look 'differently'
Dried tomato branch. Pencil.

GREEN RED BLUE RED GREEN BLUE YELLOW ORANGE BLUE RED GREEN VIOLET

BROWN YELLOW RED GREEN BLUE RED YELLOW BLUE BLACK

BLACK GREEN YELLOW VIOLET YELLOW GREEN

YELLOW ORANGE VIOLET VIOLET BROWN YELLOW

ORANGE RED GREEN BLACK RED GREEN BLUE

BROWN GREEN YELLOW RED BLUE BLUE ORANGE

1. **Left image: Say the colour, not the word.**

2. **Right image: Say the colour, not the word:**

 a. **From top left, in the normal reading direction. 2x completely through. Pay attention to the effects.**

 b. **From bottom right, against normal reading direction. Pay attention to the effects. Different? The same?**

 c. **Again from the top left, extremely slowly (6 to 8 seconds per word). Effect?**

If it went as intended, you've just experienced two different 'operating systems' of the brain at work. Simply put, these are 'speaking-thinking' and 'seeing-thinking'. We will now use these operating systems as a very pragmatic dual working model for consciously learning to draw.

It may be that with the left image, 'seeing-thinking' provides an advantage because the dominant linguistic way of thinking, which is reflexive for our brain, is mostly ineffective. On the right, meanwhile, the 'normal' words – despite inversion of the task – activate the dominant verbal system of 'speaking-thinking'. This is presumably because of the learned meaning of the words, which you aren't able to overlook. Most people have to refocus after two to five words. How about you?

A similar conflict makes drawing arduous or even impossible if you have no strategy to cope with it. It's likely that there is a mental struggle going on between the reflex of drawing that which you recognize/name/know (the word), and your intention of drawing what you

GREEN RED BLUE **ORANGE YELLOW** VIOLET

BROWN YELLOW GREEN **RED BLUE BLACK**

BLACK **GREEN** YELLOW **VIOLET** GREEN

YELLOW ORANGE VIOLET **BROWN** VIOLET

ORANGE **RED** GREEN **BLACK** BLUE

BROWN BLUE **GREEN** YELLOW **RED** ORANGE

see before your eyes. This could be the reason why your hand often doesn't do what you want it to when you're drawing.

In the clinical experiments of Roger Sperry, which led to the (shared) Nobel Prize in 1981, something interesting happened in patients whose corpus callosum had been severed. That's the connection between the hemispheres of the brain. Sometimes with these patients, one hand was trying to put on their shoes and the other was trying to take them off. At the time, this effect was explained by the fact that the brain halves couldn't communicate, so one of them wanted to leave the house and the other wanted to stay home, for example. This seems plausible, as each half of the brain controls one of the hands. In the case of drawing, similar conflicts seem to occur.

It's the same when drawing: draw what you see, not the 'word (or symbol)' for it.

I'd like to reiterate the observation that there is something special about drawing. You can – whether on your own or through guidance – learn to flip a metaphorical switch in your head. From speaking-thinking to seeing-thinking. You must learn to switch from recognizing and naming things, or from seeing simplified symbols, to perceiving 'raw visual data'. Just like with the colours on this page.

Children that we call gifted show all the signs of having reached this ability early on, whether on their own or because they received guidance at a young age. This ability could be

termed the 'artist's eye', a 'good eye', a 'knack for drawing', or simply 'talent'.

The fact is that the change occurs suddenly, like a switch. You may be familiar with it from moments when you've made a small sketch or drawn a part of something and it worked well, looked nice, and felt different than 'normal drawing'.

The idea for this amazing 'brain teaser' (known as the 'Stroop Test') came from John R. Stroop, who first published it in 1935. The effect is used in psychology as a test of impulse control, not to draw attention to two different 'operating systems' of our brain. I added the mirrored version myself.

One Brain, Two Operating Systems — Huh?

The brain likes to seek the usual answer, the quick fix. Again and again, the words push ahead of the colours. This is because, for most of us, speaking-thinking is dominant. Which isn't all that helpful when trying to draw a subject.

What happens in the brain when we draw something? A simple explanation could have something to do with the fact that our brain is actually two brains, anatomically. It consists of two almost completely separate halves, each of which, as we know today, 'sees' the world very differently.

Put simply, these halves have different abilities and tasks. They work together and are also able to divvy up tasks, depending on their nature. The visual system, for example, for which the right brain is responsible, helps us with drawing. However, if we were completely without the left half, drawing wouldn't work at all.

In practice, we can thus assume there are two 'operating systems'. Let's simplify this: one half of the brain is good for language ('speaking-thinking'), the other for visual perception ('seeing-thinking'). The problem is that we aren't usually aware of these two systems. In the 'say-the-colour' experiment, however, their function becomes very clear, and that can be irritating.

Roger Sperry received the Nobel Prize in 1981 for research into the specialization of the brain hemispheres. He was the first to be able to show that each hemisphere processes information in its own way and that together they create our 'reality'. Sperry went so far as to describe it as two different forms of consciousness that normally interact with each other unnoticed.

Right brain, left brain? This is still disputed among scholars. Fortunately, it doesn't really matter for our purposes what exactly happens in which part of the brain — the only important thing is to become aware of the model of the two 'operating systems' and to thereby enable

Here in the middle you can see the Corpus Callosum, the connection between the hemispheres of the brain. In this structure, there are about 300,000 connections — not that many among the roughly 80 billion brain cells. Cross-sectional view (MRI) of my brain, seen from above.

Cross sectional view a little further up. Here you can clearly see the brain halves, anatomically separated except for the Corpus Callosum.

We can't feel our brain — neither one half nor the other.

a constructive collaboration between them for drawing. Consciously at first, then automatically.

How can you use the operating system that's 'talented' at accurate viewing? There are several ways to give speaking-thinking a little break. If you can pull it off, seeing-thinking will automatically take over when drawing.

Using this mode — consciously at first — drawing will look and feel different. Whether for me or for participants in my courses, this effect is always noticeable. What you're doing when this happens is 'looking-drawing' and no longer the familiar, often awkward 'thinking-drawing'.

It's something that hardly anyone is used to — it's just a completely different experience of drawing. Without the switch to seeing-thinking, that is, to visual perception, drawing remains technical, often strangely lifeless, and in my personal experience is also less satisfying than it could be.

I want to show you how to access these possibilities in drawing. That's more important to

'Do you always have to see everything differently?
Just be normal for once. Do you have profile neurosis or something?'.

me than theoretical discourses on the brain. To me, the most extraordinary result of Betty Edwards' research is the postulation and practical application of meaningful individual competencies that seem to lead to a whole new level of drawing for anyone that acquires them.

Pose this question sometime at a university symposium for art teachers: why, out of the hundreds of teachers of visual arts that are there, can hardly any of them draw really well, and why do almost none of the children in their classes learn to do so. I did that once, I couldn't help it. A murmur of approval was heard from the audience, seeming to say, 'At last someone came out with it.' Then followed the evasive answer of the irritated professor, to the effect of 'Well, um, we also have other important goals.' A poor hand to deal to children, who just want to learn how to draw and are seeking support.

Learn with the brain's way of working, not against it. Greatness comes from the basics. Basics in perception and in the approach. Doing this, you can learn to outsmart the very natural 'drawing inability' of the brain. In nature, developing humans never needed the ability to transform 3D into 2D.

Accurate drawing is thus a cultural achievement, not a natural one. Our goal in doing this is that the two 'operating systems' learn over time to work together without conflict. Then – and only then – will you be able to draw with a good prospect of consistent results.

When starting out, you should have a conscious and planned approach so that you will get a sense of achievement instead of just hoping for luck. This is the decisive training goal: the well-rehearsed interaction (division of tasks!) between seeing-thinking and speaking-thinking.

Knowing what you're doing is good. Merely feeling 'in the flow' is fine, but you're just treading water artistically. 'Flow' on its own can be reached with just an ordinary colouring book or Zentangle.

While sketching in the MET in New York in 2012, I overheard this conversation in the hall with the Greek statues. Father, lecturing: 'Perseus didn't turn to stone because he didn't look at Medusa.' The little daughter, excitedly pointing at the stone sculpture of Perseus, said: 'But dad, he did turn to stone, look!' Dad is speechless. Abstract knowledge versus concrete intuition, wonderfully demonstrated, I thought.

All right then. But how do I now get to where I can draw what I see, not just what I think? Keep reading.

Your Brain Decides What You See. Not Your Eyes. See for Yourself

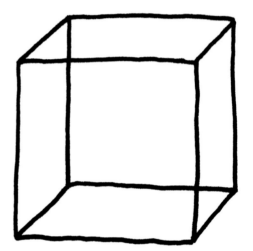

Look passively at the 'transparent' right cube until it changes.

This can take up to a minute. Once it has changed, are you always able to see the cube the same way, if you continue looking at it? Or does its orientation change every few seconds?

This once seemed strange to me, unbelievable. But it proves yet again: our brain decides what we 'see'. The left cube appears quite normal no matter how long you look. Take a long look at the right cube and just wait. As soon as something begins to change, see if you're able to keep looking at the cube <u>without</u> something changing regularly. These ambiguous figures are called 'Necker cubes', after the Swiss physicist L. Albert Necker (1786–1861).

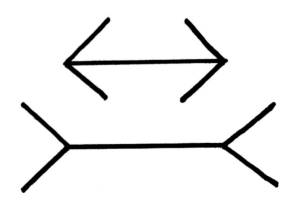

Different lengths – or not? After a discovery by Müller-Lyer in 1889.

These two tables look very different to me. Just to be sure, try 'measuring' the short side and long side of these tables with a stick or pencil (no rulers). After an idea by psychologist Roger N. Shepard.

Whether you know what's going on here or not, only comparison helps. When drawing please always remember this! It makes a difference. Even if you're initially embarrassed to be seen 'sighting' with an upheld pencil or coffee stir stick. (I'll explain sighting more precisely later.)

'Actually, we see through the eyes rather than with them.'

Kimon Nicolaïdes, artist and legendary drawing teacher at the
Art Students League of New York, in *The Natural Way to Draw*
(published 1941, new editions continue to this day)

Use an object to compare the two lines on the left (not a ruler).

The fact is, our brain massively filters the 'raw data' of the world, but doesn't let us know that it's doing so. You have to consciously learn to get around this, including when drawing. Drawing is intuitive only when you're spontaneously able to avoid misperceptions.

I didn't include these optical illusions for entertainment. They're intendeed to raise awareness of why sighting (that is, comparing relative sizes when drawing a subject) is necessary in most cases for accurate drawing.

Exciting phenomena, but very annoying when drawing: constancy of form and constancy of quantity often cause us to 'see' things the way we think of them.

What we think we see, therefore, sometimes has amazingly little to do with the image on the eye's retina. A similar phenomenon awaits us in the case of painting, which you've probably guessed by now: that of constancy of colour. Take note of how many green tones a real tree actually has, for example, or how many nuances of colour there are on an apple – then you may be able to appreciate what I mean. You'll find a little experiment on this topic on pages 136 & 137.

If your 'talent' doesn't find you, try thinking in a different way before you give up.

In modern sports training, this is referred to as 'chunking', i.e., underlined dividing things into chunks. To become aware of this now may be a little bittersweet for those who have tried to draw in the normal way, 'swallowing it whole' with practice and humdrum drawing lessons.

Notice anything? This sports methodology is exactly the opposite of the usual way of 'learning to draw'. In that approach, you're supposed to first practise, and then – if you have talent – you'll learn something; and if you're lucky, you'll at some point get 'it' (meaning mastery becomes possible). If you have enough talent. In this process, 'it' and 'talent' are never explained further.

Studies of talent in sports, music and literature, among others, point out that talent could largely be an illusion. As an introduction to the topic I recommend *The Talent Code* by journalist and author Daniel Coyle. 'Aha!' experiences are guaranteed, as well as quality entertainment.

Eating with cutlery, reading and writing, driving a car, swimming, riding a bike... we learn many things which then become largely automatic. From that point on, conscious reflection is more likely to be disruptive and to make us slow and awkward.

These are all 'composite' or complex skills that are made up of component skills. Using the example of riding a bike makes this easy to understand: balance, steering, braking, cornering, stopping, dismounting... all of these are component skills that together add up to a 'whole' skill.

Once you have this skill, the eye seizes upon, say, a street lamp, and the brain gives the command to take evasive action, steering the body so that we don't crash into the lamp. This happens automatically. Some researchers today say that up to 95 percent of everything we do is 'automatic'.

So why is it that we so often experience 'accidents' and stress in drawing when we look at something and want to draw it the way it looks? Why doesn't the pencil do what we want it to: simply that which the eye sees? It can't be the pencil's fault. The eyes are usually fine, too. Same goes for the hand. So it could be because of the commands that the brain gives. In particular, contradictory commands.

Here's a scientifically and empirically derivable hypothesis: it's likely that we often draw in an unsatisfactory way, without guidance, because we draw symbols from our imagination and not what we actually have before our eyes. This leads to a conflict in the mind and a drawing that doesn't look very good, which then triggers that well-known drawing stress. Since we humans seek to avoid pain and obtain rewards, the majority of us soon leave drawing behind.

Looking closer will, with time, become more and more enjoyable. You'll even be able to empathize with what some children experience. They have moments early on when they see parts of subjects 'clearly' – or in the language of this book, they 'perceive them directly and visually' – and then re-create (or visuo-motorally transcribe) them with the pen. When this intuitive perception is suffiicient to allow for consistent proportions of an entire subject, we refer to this as 'exceptional talent'. As an adult, with the right approach to learning, you can make similarly amazing progress.

Basically, learning is like sushi – bit by bit is better than in one piece.

Drawing Is a Skill That Can Be Learned in 'Individual Parts'

The component skills can be developed individually.
Preferably using this tried and true cycle:

a. understand

b. learn/do

c. develop a 'feeling for it'

d. and only then practise (train until it's automatic)

The Five 'Chunks' of a Sought-After Skill

<u>Each individual chunk helps you to 'appease' verbal thinking, allowing visual thinking to become clearer</u>

Once you know them, the five component skills are always there for you. Difficult though it may be to accept this, as it doesn't seem creative, but instead sounds almost school-like and overly 'logical'. <u>When starting out (or over), use this 'checklist'</u> and structured approach, otherwise learning to draw can take many years and will have an uncertain outcome, even with motivated practice. Betty Edwards meticulously compiled this list, and I believe it's worth knowing. As an artist, serious academic, and teacher, Edwards combined what many have guessed and partially practiced over the centuries in a uniquely comprehensible way. I've never found a more complete and illuminating breakdown into doable 'chunks', so I'm happy to pass these suggestions along to you, along with some examples of my own.

My hand as seen through a disc of glass or Plexiglas and drawn directly on it. <u>After</u> blind contour drawing this is very doable, as your visual awareness will be more available. As a principle, this has been known since the Renaissance, but is almost forgotten today.

Perceiving Contours

Through Kimon Nicolaïdes technique of blind contour drawing, for example

Seeing contours and being able to draw them precisely is the first milestone. Extremely slowly, at first. It sort of feels as if the pencil is where the eye is looking and is moving like the eye. It sounds weird, but you feel strangely connected to the object you've drawn. When this feeling arises, the result is usually good too.

By 'awakening' your eye-hand connection through pure contour drawing, your lines become more sensitive, more artistic. Because of this, it soon becomes possible to make amazing 'drawings' of your hand using a marker and a piece of Plexiglas or similar material.

Forest against sky. The observation of subtleties in contours will serve you well later on, including when sketching.

Pure contour drawing, also called blind contour drawing (here with hand lines). A direct connection is activated between eye and pencil – <u>without</u> looking at the page. It should look as 'meaningless' as what you see here. 'Slow seeing' allows more visual perception. That's the only goal at first.

The meaning behind 'meaningless' blind drawing becomes apparent when you later add consistent proportions and targeted omissions to your acquired sensitivity to observed contours.

Perceiving 'Captive' or Negative Shapes

Paying attention to so-called enclosed negative shapes, i.e. to the places where the subject is 'not', helps you switch to the visual mode when drawing. By focusing on these 'spaces', a subject can often be drawn more accurately, because the brain has no prefabricated, symbolic associations with the negative shapes.

If you draw 'nothing', drawing 'something' will work better.

Taking the time to focus your attention on these areas helps you to activate the brain's visual operating system.

The great thing about negative shapes is that they have common contours with objects (positive shapes). These are referred to as passive lines, i.e. those that are drawn out of habit or as a drawing style, but which don't actually exist on the subject as real lines – see this example.

Here, simple 'captive' negative shapes are easy to recognize.

Small wagon and shadow projection. The bright inside spaces are called negative shapes. If you close one eye, you'll also be able to see them two-dimensionally on the real wagon. In shadows they are already in 2D, as logic would dictate. It's therefore easier to practice with the shadow first.

To become familiar with this helpful 'way of seeing', it suffices to make relatively small drawings of simple subjects – ones which you won't feel the need to 'finish', which would be a hindrance at this point.

By 'looking flatly' at the shapes between things, great progress can be made quickly

Seeing the chair two-dimensionally and focusing on the intervening spaces is very possible after the introductory exercises. A first negative shape on the chair is used as a basic unit. This allows all other distances to be compared by sighting. (I'll show you that in detail later on).

In the shadow of the bush on the wall you can see bright negative shapes. In the bush itself, the negative shapes are dark, while the leaves are now bright. Being able to see things like this will help enormously later on when drawing in nature, as you'll be able to simplify the 'chaos' of plants in your drawings.

The principle on display, unmistakably clear: Foliage with very high contrast and white negative shapes.

3

Perceiving Relationships

Proportions and perspective (informal, with sighting)

Using a sighting aid – the coffee sticks that I love so much, for example – it doesn't take long before ratios of size on the subject can be determined reliably. This allows you to represent them consistently in your drawing, albeit on a different scale.

Experience the unfamiliar feeling of having something you draw look realistic, and not 'just okay'.

Drawn using so-called sighting, not with projections. Without worrying about the (obvious, in this case) vanishing point.

Sighting can be a test of patience until you get a handle on it.

The incredible result: this is only the third drawing my wife has made since childhood.

You can learn to sight angles (converging lines) by holding a pencil or stick at a slant. Then you move it down to the paper in a parallel motion. This works wonders, once you get the hang of it. Especially when sketching, this method is easier and more versatile than projections with vanishing points, because if there are too many vanishing points in the subject, or if there aren't any that are obvious, accurate free drawing quickly becomes impossible.

In reality, these posts are the same size. Using a stick or pencil, compare how often the height of the smallest post fits within that of the closest one.

It's best to learn how to sight proportions <u>and</u> <u>angles</u> directly on the subject. These will be totally different than you might at first think.

Perceiving Light and Dark (Tonal Values and the Logic of Light)

A strange observation: without assistance, tonal values – the different degrees of brightness in the world – are curiously invisible to most of us.

Greyscale or tone scale. Remember to check it frequently and imitate accordingly.

In learning to see tonal values, it helps to work with a soft pencil until you begin to perceive tone and contrast range more clearly. It also helps to take black and white photos of subjects (to look at, not to draw!). Otherwise, colour can cause a lot of trouble, and perceiving it can be made unnecessarily difficult. The same goes for your concept of what should be light and what should be dark. When starting out, it's also very helpful to have subjects with dramatic lighting.

If you can barely see your drawings from a few feet away, it's usually an indication of unintentionally light tonal values. This can also be a stylistic device. However, most of the time it's involuntary, more than anything because you aren't able to perceive the dark shades or don't want to spoil the drawing with 'darkness'. This brings to mind a musician who can only play his instrument very, very quietly.

The logic of light, short version

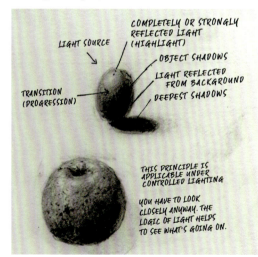

We are apparently accustomed to light coming from above and to the left. Practise with controlled light at first (a bright lamp). You'll soon have a better grasp of light and dark in general.

It's helpful to align tonal values with each other. This is usually done by close observation. Other times, it's implemented deliberately.

Half coconut with usable contrast range. Please note: it's only through darkness that light appears bright.

5 Perceiving the Gestalt (The 'Essence') of Something

The concept of gestalt comes from psychology. The term is German, it's literal meaning being 'shape' or 'form'. In drawing, 'gestalt' refers to what makes a drawing consistent and convincing – difficult to describe, easy to experience. In German, this word is used in phrases such as 'etwas nimmt Gestalt an", which refers to 'something taking shape', as well as the verb 'gestalten', which in its narrow sense means 'to give or impart a recognizable form'.

Find out why the whole is more than the sum of its parts. And why omission is so appealing.

To illustrate this concept, you can see here a simple 'gestalt' phenomenon: the white triangles aren't really there. You can see them, however, because the brain recognizes 'triangular' at lightning speed. In other words, it perceives the gestalt of a triangle. Simple, yet extremely helpful as an exercise in seeing and drawing.

When drawing the second and third 'pies', you have to keep the whole in view! If you're only looking at the pencil while drawing and hold it in right out in front of you, it's almost impossible to create an accurate white triangle.

Sometimes it takes very little to enable gestalt recognition in the viewer.

White triangles that aren't actually there. Except in the mind, thanks to 'gestalt recognition'. On the right, the limits of the gestalt effect are almost reached. This is, to my surprise, one of the most effective basic exercises for getting started with seeing.

Self-portrait in the mirror, practice drawing. Eraser and pencil on graphite-primed paper.

The 'gestalt' of a head (self-portrait in the mirror). It's not 'correct', but it's enough: at first glance, you can spontaneously recognize a believable head.

What is that? If you recognize it, that's the gestalt effect. If not, you'll find the answer on the next page.

'This training in perceptual skills is the rockbottom "ABC" of drawing, necessarily – or at least ideally – learned before progressing to imaginative drawing, painting, and sculpture'

From *Drawing on the Right Side of the Brain*® by Betty Edwards

The more you perceive, the more you can later leave out (if desired). This isn't the only apparent contradiction in drawing.

Whatever this is, the people in the university cafeteria ate it anyway.

Here again, you can see the 'whole', although relatively little is actually on the paper. This effect can be controlled with increasing experience. This is likely part of the explanation for the artist's saying 'drawing is omission'.

Almost the same 'individual information' here as on the left, but it's been shifted. No more gestalt effect.

At the store, I spontaneously read 'Johannisbeeren' ('currants') and only noticed the mixed up letters a second later. Another case of gestalt recognition, presumably ('seeing the whole thing'). In this case with a word.

Man with glasses. Trust in the introductory exercises. And in the training in the five component skills. Remember, it's all very easy to learn – if you do so consciously and in the right way, and don't just keep excitely 'trying it out to see what you can do'.

You don't want to hear any more about the switch to the right brain, or you think it's nonsense? Then just call it 'awakening the artist's eye' – and learn and use the effect anyway. It's very noticeable for anyone that uses it.

I'm telling you.

These little 'like real' experiences (as pertaining to gestalt) are especially helpful when just starting out, to get your 'inner critic' excited about learning to draw. Priming with graphite helps you to not be so stubborn and obsessive with 'technical correctness' and details, so that you can retain a feeling for your drawing. We'll get to that beginning on page 100.

The Usual Self-Talk While Drawing. Does This Seem Familiar?

'It's okay, but something is missing.'

'It just never looks real to me.'

'I can't do straight lines.'

'This isn't going to work.'

'I hate noses.'

'I can see that it's not right, but I can't do anything about it.'

'This is driving me crazy.'

'I just don't have any talent at all.'

'Hair is difficult.'

'So, just the eyelashes left.'

'I don't even know where to start.'

'My teacher said I might want to do something else.'

'I think it's useless.'

'I wasn't even able to do that at school.'

'I can't do curved lines.'

'Everyone in my family is artistically talented, except me.'

'I'll never be a Picasso, so what's the point?'

'My hand doesn't do what I want it to.'

'There, you see? I can't do it.'

'I'm not creative, I can't do things like that.'

'Crap, it didn't work, it looks horrible.'

Your self-talk, by the way, gives you an indication of whether you are already in 'seeing-thinking' or if you are still in the normal logical mode, the otherwise very useful 'speaking-thinking'. In hindsight I must admit that I once had similar negative thoughts when drawing. This seems to be quite normal for most people before they realize what drawing really is — it's seeing, not merely 'drawing', as I had always thought.

'How do you draw a mouth again?'

'I can't do faces.'

'In my school there was this one kid, he was so gifted.'

44

'I can't really see it.'

I'll Show You a Different Approach. What's Your Reaction to These Monologues?

'There are so many more of these small lines, were they always here?'

'This job is great.'

'I need to check again where the ear begins, that can't be right.'

'All right then, I'll just compare it to the stick again.'

'The little shadow here, it has a steeper angle on the left than on the right.'

'Let's see, where does it have very dark areas?'

'It's fun drawing with the eraser.'

Follow the line. It leads your eye to drawing.

'All right, I'll forget about drawing the mouth, and look closely at the shadows.'

'That part is still a little off, this one's pretty good.'

'What's my hand doing with the pencil? Yet somehow it feels right.'

'One line at a time, it really works, I never would have thought.'

'Hmm, is there really a crease in the apple? I thought it was round?'

'Funny feeling, drawing in slow motion...'

'Aha, a little smaller than that, and slightly upwards, about here.'

'I have to say, I am very happy with this line.'

'If only my drawing teacher from way back could see this.'

Once you've read and experienced what is meant by 'seeing-thinking' through the simple exercises, you can control your self-talk so that it helps you in drawing and learning. By doing so, you keep your stress level low and stay in 'drawing mode' instead of always beating yourself up. This gives you a good chance at real progress, faster than you now think possible.

'Is this lighter or a bit darker?'

'Hm, I'll leave this one for now and have a look over there.'

Solution from page 42: it's a truncated '3', laying down.

Make some copies for yourself or just draw directly in the book.

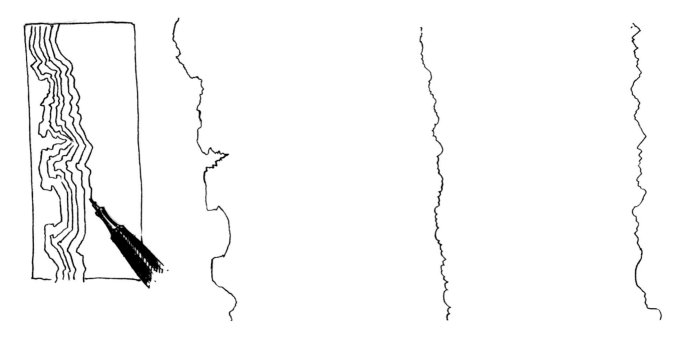

The Key to Learning How to Draw Is 'Hidden' Here

The key is mainly to be found in the seemingly banal <u>introductory exercises</u>. Using this book, you can discover, understand, learn in-depth about, and then train your so-called 'artist's eye'. Mind you, that's <u>after</u> you've had some <u>success</u> (and, if possible, some feedback). What I mean by that is, with learning and training that allows for a certain pride at all levels.

In other words, using this careful and gradual method, you can honestly learn 'talent'.

If it didn't sound so silly, I would say that <u>this will make you really happy</u>. Bonus: experience has shown that you will learn much faster than with the conventional practice-and-hope-for-progress method.

Learning in doable, individual steps may seem too easy to you. But have you ever seen someone who could play a piano concerto without a learning process?

'Anyone can be cool, but awesome takes practice.'

Anonymous

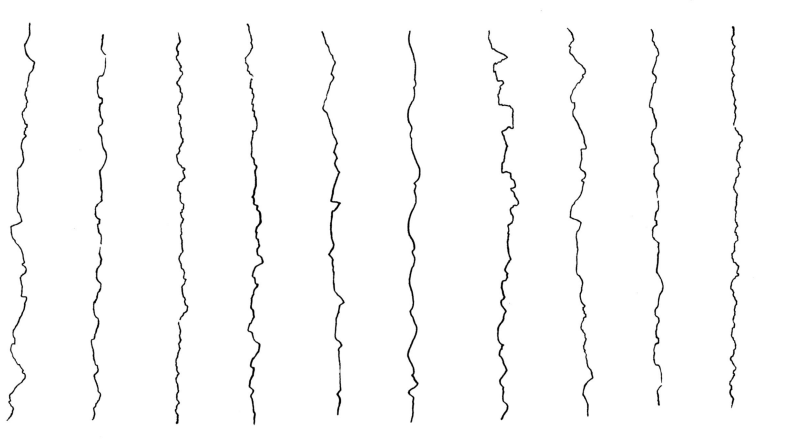

Instructions

Make some <u>copies</u> of the lines. Or draw in the book. Take a fineliner, hold it a little further back than when writing – enough that you can easily see the tip and a few inches further back while drawing. Draw one line at a time, with 1.5 to 2 mm (0.059 to 0.079 in.) between each, very slowly, without setting down the pen.

Do it against your usual writing direction, <u>holding the pen securely but with a relaxed grip</u>. Draw from top to bottom, like in the demo at top left (left-handers will need to turn the template accordingly).

When drawing, look more at the existing line than at the tip of the pen. Make several lines.

Notice when it starts to feel as if your hand is moving <u>automatically</u>. This is called 'drawing directly according to perception', correctly expressed as 'visuomotor coordination'.

It's a lot like cycling around obstacles – steering and reacting without deliberately thinking about it. Here you're just reacting to a line.

<u>When you become more confident, increase the distance to 1 cm (0.39 in.)</u>. Draw slowly and accurately, looking simultaneously at the existing line and the tip of the pen. Compare this feeling with the feeling that you normally associate with drawing.

'Hello reader, you don't need such easy exercises. Throw the book away while you still can.'

The First 'Colouring Book' That Looks Better After Colouring Than Before. A New, Previously Unknown Basic Training?

Embankment from inside the car. Pencil. An important principle: allow bright areas to emerge by seeing and drawing the dark ones. The same principle applies to this fish. The drawing has been greatly simplified in order to force the brain to make the 'inverted' procedure into a habit that can be called up when needed.

These exercise sheets are the opposite of traditional colouring books: everything 'meaningless' is to be filled in, only the figures themselves are not. Both adults and children have consistently confirmed that working on them is a pleasant, even meditative experience, and that afterwards the result looks 'better' than before.

The outlines do make the figures initially recognizable, but the 'pictures' don't spontaneously emerge, crystal clear. This only happens when the 'white pictures' are intensified by darkening the intermediate areas.

To my great astonishment, I myself profited a great deal from this exercise. This training idea came about by happenstance from something that children in the studio had a lot of fun with. Not from a colouring book, because – dare I say it? – I already deeply hated those as a child.

Something fundamentally different had to be at work here. Especially with free drawing and sketching, it caused a sudden leap forward. All at once, I was better able to see dark areas in the outdoors. Because of this, I was able to produce rocks, bushes, and other objects indirectly. I had often seen this in books, but it had never really worked in the outdoors before. Even though I theoretically understood it.

You will now be able to understand and train (without risk and stress) how to produce light through darkness – without a real subject at first. Here you can see the first drawing I did outdoors that seemed to go on autopilot. After working with the 'reverse colouring book', my brain seems to have accepted how to bring the stones out through the shadows rather than by compulsively drawing 'stones'. I had the impression that it came about rather suddenly.

Every time a figure emerges clearly and brightly (i.e. its gestalt takes shape), a pleasant feeling arises. In itself, that's not a big deal. But for most people, it's probably the exact opposite of previous experiences with colouring books. As a side effect, some of these absolute basic skills can become automatic, which is very valuable in drawing later on.

The pre-drawn shapes initially scare off some 'artistic souls'. Unpleasant memories can arise. I get it. That's why I'm asking for a bit of curiosity and trust. Correctly understood and done, it doesn't hurt. Quite the contrary. Additionally, the simplicity of the supplied shapes allows you to get a feel for hand-eye coordination and pencil movements (rhythm), without worrying about proportions or the pressure to succeed.

Only with time did I understand everything that this seemingly banal 'anti-colouring book' exercise could offer:

» almost immediately being able to experience the 'other' feeling of drawing

» finding a secure but relaxed way to hold the pen

» trying different levels of pressure without the risk of 'messing up' a drawing

» in the process, strengthening the 'eye-hand connection'

» the chance to experience switching to visual mode at least once a day

» getting to know different pencil hardness levels and their possibilities in a playful way

» trying out hatching informally: different directions, lengths, and speeds

» creating different shades of gray in different ways with pencils

» experiencing in a worry-free way the degree of darkness that pencils can produce

» experiencing what tiny subtleties in shapes can do for the overall effect

» developing a relaxed relationship with 'over the line' drawings

» geting used to thinking in terms of areas, not just lines

An example of my introductory exercises, which are a lot more basic than the 'normal' drawing basics

Here's how it works: draw around the figures until they come out clear and white. This usually starts to feel strangely good after the first figure. After the 'rational' half of the brain gives up on its sabotaging thoughts, assuming there were any in the first place.

Draw darkly all around, not inside. Make the existing outlines disappear. Doing this automates important basics. I thus recommend that you do it very often.

As soon as children reach the age at which they develop the capacity for self-criticism, they begin to notice discrepancies in drawings. Especially their own. Making use of well-intentioned, pre-drawn colouring books thus quickly becomes an insult to the children's aesthetic sense. Upon gentle inquiry, this has been confirmed by every child I've asked thus far, and they also seem to feel well understood afterward.

Simply **effective**. Make it simple!

Cause the lines to disappear into the dark gray tones of the pencil, until no white areas remain outside each white figure. Visuomotor coordination and grayscale-production skills are trained automatically in the process. Soft pencil, sharpened often.

As an aside, you can (should!) lightly draw over the lines – and then erase the figures from the inside until they are 'clean'. Use the pencil in short, repeated movements. It's better to go over it several times rather than pressing hard.

Try different things.

Just one or two 'figures' a day brings a surprising amount of progress and is sufficient!

Make plenty of copies of the templates on the next page, some enlarged to A3 *(Tabloid or Ledger 11.00 x 17.00 in.)*.

Remember to never colour the figures themselves, only around them! Otherwise the exercise accomplishes nothing, as far as drawing goes. The feeling is new and will be different than you've experienced previously in drawing. Remember, this is like in competitive sports: training in its pure form, no 'real' drawing yet!

On two of the training sheets, the lines gradually fade away. There is a purpose in this. I recommend starting with the left one. As was the case with the previous exercise with the lines, remember to hold the pencil a few centimetres further back than you do when writing, so that you're better able to see the paper.

Quite small for the simultaneous training of smaller (hatching) movements.

Medium size. If you copy templates and then rotate them in different ways to work on them, the same basic training will be a bit more varied. It's best to make different-sized copies, not always the same.

Quite large for the simultaneous training of freer movements. Practice from different directions and make (relatively) short, fast, and even drawing strokes, otherwise you'll soon have long 'straw'.

Upside down world? This strange exercise is usually a revelation to complete beginners. For many who already draw, it serves as in-depth discovery and relaxed training in perception.

'In order to gain access to the subdominant visual, perceptual R-mode of the brain, it is necessary to present the brain with a job that the verbal, analytic L-mode will turn down.'

Betty Edwards

That's surely over-simplified — but as a working hypothesis it has proven effective nevertheless.

This exercise is based on an idea by Betty Edwards, who happened to write a PhD thesis on this phenomenon.

'To be creative, just <u>stop</u> being uncreative.'

Paul Arden

Oh Great... and How Do I Do That? Like This, for Example

The following exercise doesn't have anything directly to do with 'creativity' yet, but it does have something to do with 'seeing-thinking'.

Copy an inverted drawing

Materials: A4* paper (several sheets on top of each other), 2B pencil, sharpener, eraser, Sellotape (removable).

Lay a few sheets of copy paper on top of each other, directly here in the book to the right of the template, if you're right-handed. Attach it with removable adhesive tape.

Begin in the upper left corner and draw the two upper lines of the incomplete frame onto the sheet of paper with a 2B or 4B pencil. Draw it in its original size using a geometry triangle or similar. Then put away the ruler or triangle.

Start looking at the top of the template and drawing what you see. It helps with getting started if you make some orientation marks, measuring precisely with the coffee stick (<u>not</u> with a millimetre ruler).

To do this, hold the stick over the original, mark the distance, place the stick on your drawing, mark the point, and so on.

Continue to use the stick to compare where necessary. Do one pass by <u>eyeballing it</u>, then compare and adjust (with the eraser). Continue until can do it consistently (always check with the stick before things get out of hand!).

Take as much time as necessary. It's about getting a feel for 'seeing-thinking', not about finishing.

Look at the direction and subtleties of the lines, build one area upon another like puzzle pieces, where possible, then continue on comparing and adapting.

<u>Only turn the template around at the very end</u>. Pay attention to the effect.

American letter-size paper (8 1/2 x 11 inches)

The main goal of many meditation techniques is to turn off the 'stream of thoughts' via 'meaningless' tasks. That sounds a great deal like what Betty Edwards is driving at in the context of learning to draw.

Gazing long into a candle's flame, staring at a white wall, listening to toneless sounds – these are all techniques to achieve a 'stillness' of the mind. They are intended to cause the everyday stream of thoughts in your mind to run dry.

More Small Exercises. Huge Effects

Important: <u>Don't</u> first sketch out **<u>a triangle</u>**! This will accomplish nothing. Think in 'pies'.

Imagine your whole white triangle is already on the paper as you create it corner by corner with the pies.

So that the directions will match, **<u>pay conscious attention to the first pie as you draw the second.</u>** The missing piece can be aligned exactly to the first missing piece.

<u>When you draw the third pie, look at the first two at the same time</u>. This gives position and angle a chance and a convincing triangle spontaneously 'appears'.

Keep making triangles until it feels like nothing can go wrong anymore. This will help you a great deal later on in drawing. The goal is to **capture the whole** while working on the details. You could also put it this way: this is training for the 'soft eyes' that can simultaneously perceive more than one small spot.

If you see triangles here, remember, they aren't really there. The brain thinks them up. It sees enough to recognize the 'gestalt' of a triangle.

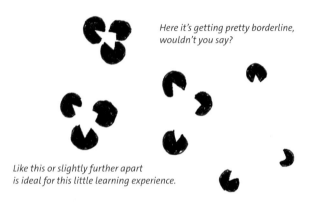

When they are so close together, there is almost nothing for the brain to fill in.

Here it's getting pretty borderline, wouldn't you say?

Like this or slightly further apart is ideal for this little learning experience.

And here a triangle no longer springs so easily to mind.

One step at a time. As an introduction, do the exercise on the right several times, exactly as shown (if you're right-handed, directly to the right or above).

You can draw directly in the book. Who's stopping you, anyway? Maybe the same voice that says you can't erase or draw over the lines? Or the voice that's trying to convince you that you have no talent?

If it works out well with the Fineliner, have a go with the soft pencil as well.

Of course, you can also make copies of the templates – the main thing is that you have your 'aha!' experience with the triangles.

On each example, please proceed from 1 to 5. It probably sounds almost too easy. But the benefits are huge.

No joke: the artist's eye can be trained with white triangles that don't exist.

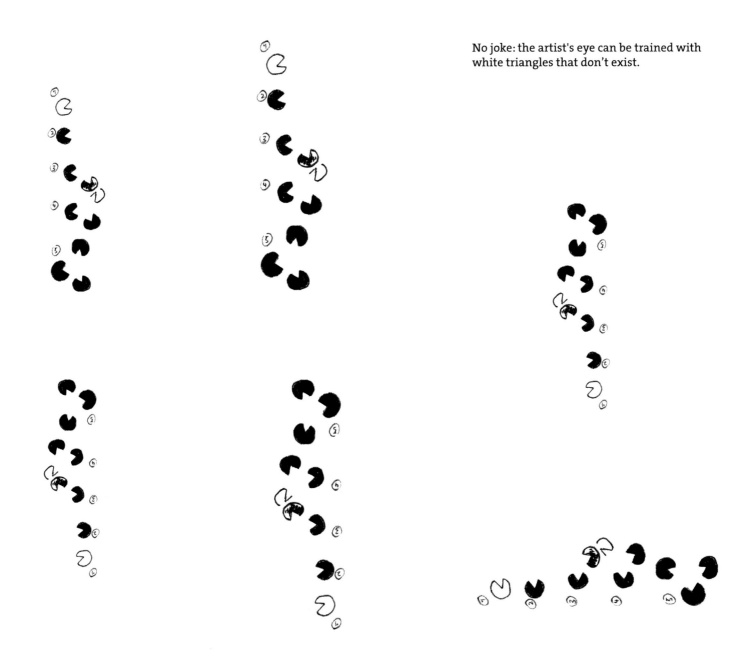

You are hereby officially allowed to draw in the book!

Experience the Gestalt Effect and Discover 'Soft Eyes'

Never forget: reduction (deliberate omission) leads to the active recognition of the 'gestalt' in the brain. Right: almost exactly the same dark marks, but with the positions shifted. The 'whole' is not recognized.

There is a game-deciding 'trick': Simultaneously look with so-called 'soft eyes' at what's on the page and at the tip of the pen you're drawing with.

Soft eyes are the right brain's way of seeing. The 'staring', narrow-focused gaze of the left brain can capture only a tiny spot at a time. They say it's only 1 to 3 degrees of the entire field of vision.

With this portrait of a boy from the side, a whole first arises in your mind – except it's now the gestalt of the boy instead of a triangle. There are only a few dark marks on the page. The brain 'draws' the rest. If at first you end up 'derailing' your white triangles, read the instructions several times. Sometimes the left brain sabotages things a bit. With these triangles, you are training a decisive process in drawing in its pure form. It's like learning how to walk before you run.

Instructions

In the same way as with the white triangles, create white rectangles, squares, circles, and then even irregular white shapes. But only do this once things are working well with the triangles!

Draw these shapes until it feels reliable and automatic, as if you were on autopilot. This is an indication of the right brain at work. Being familiar with this effect and feeling will help you enormously later on, with 'real' drawing in front of a subject.

Here you're training, without the threatening stress of drawing, to see the whole while you draw. If you can't get the white triangles to appear 'clearly' at first, throw a fit for five seconds, if you like, then settle down and try again.

NO GOOD LIKE THIS

OR LIKE THIS

OKAY. BUT THE EFFECT IS CLEARER WHEN FILLED IN

Draw some more white triangles now, preferably right here in the book. If it's working well, take on some other basic shapes.

Pure or Blind Contour Drawing = Very Slowly, Without Looking at the Drawing

Extremely unfamiliar: the eye is learning to discover contours purely visually and by slow 'scanning'. The pen draws along with the eye's movements, just as slowly. On the side here you can see the typical sort of tracery or 'scribblings' produced by your hand when drawing without looking at the page, which are completely meaningless for the left brain. Blind contour drawing was introduced by Kimon Nicolaïdes. The exercise in this form was developed by Betty Edwards.

Mindlessly and slowly take a stroll with your eyes, moving the pen in sync. Remember, you don't need to 'be able to draw', just calmly take a look, close one eye, let the other eye wander, and move the pen along with it. 'It' begins to draw.

If after a while or a few attempts, it feels like 'the pencil is drawing by itself', that's seeing-thinking, also called right mode. Try to connect the eye and the pen in this way often. It works for every human. Sometimes the dominant verbal system gets very irritated at first and tries to sabotage the switchover.

All of this is new and basically seems ridiculous to the left brain. Only once you've experienced the switch can you train with it. It's better to do it more often for a few minutes than once in a while for a very long time. It's worth it. Properly done, this exer-

Important: You're allowed to 'scribble' like this without producing a result that is recognizable as the creases of your hand or a finger.

Tracery produced through pure or blind contour drawing (my own)

Instructions

Sharpen your pencil. Lay the pad of paper down. Make it clear to yourself that you will not look at the line you're producing.

Sit down like the lady in the picture. Turn completely away from the 'drawing'. Then in a relaxed manner, look at your hand, rather closely.

Choose a 'point' somewhere on one of the fine lines of your hand. 'Only' look for a few seconds.

Don't start with an outside contour, otherwise you'll end up trying to draw it 'correctly'.

Don't draw your hand. No fingers. Avoid those impulses!

Then follow the slow movements of your eyes with the pencil. Slow down! Draw about 1 mm (0.039 in.) per second.

Only very infrequently lift the pencil off the paper. Consciously pay attention to the connection between your eye and the pencil tip.

cise has a tremendous effect for nearly everyone. Matisse did something like this to get in the mood for painting. Many artists do the same today. Try it out.

There's something you should know about the 'meaningless' drawings here: the 'eye-hand connection' without pre-drawn shapes or symbols feels new and different. Of course, the brain is what's between eye and hand in either case, but you don't feel it.

By means of this pure or 'blind' contour drawing, the pressure to draw 'correctly' goes away. The slower you do it, the more effective it is. It works with anything that has enough 'nameless' lines. Go slow – and yes, even slower!

Experience the slowdown! One millimeter per second is good for getting started.

If 'meaningless' drawing is at first unfamiliar and even slightly scary for you, this is an indication that it's starting to work – at the beginning, you'll often be able to 'hear' the left hemisphere saying, 'What nonsense, cut it out!'

Stereotypical stroke or lively stroke? This is similar to the difference between seeing a mountain from the plane, or climbing it and feeling every stone.

The spontaneously retrievable symbolism available to me for 'flying over a mountain'. This is an extreme example (in comparison to pure contour drawing) of how symbolic drawing and visually perceived drawing differ.

Different in each case, yet related to each other. Tracery produced through blind contour drawing (my own). Here with a Fineliner. To start with, however, I'd recommend a very soft and well-sharpened pencil.

Seeing and Drawing Lively Contours – the Example of Your Hand

My hand as seen through a sheet of Plexiglas and drawn thereupon.

No More and No Fewer: Calm and Flowing Lines

Experience how it feels in the mind when the pen slowly follows the eye as it scans subtle contours and shapes. Follow the intricacies of the exterior lines, also tracing interior lines so long as they're important for the proportions. Don't just strictly draw the outline. You don't need more lines on the Plexiglas than what you see in the examples. This is a first step towards 'real' drawing of a 3D subject. This has nothing to do with mechanical tracing. Even if that's what your left brain may try to convince you that this is, while it's looking through its drawers for a quick word for this unknown.

Very important: you're allowed to feel a quite unfamiliar, contented, and happy feeling while drawing your own hand in this way. I can only assume that this is a feeling that we once sought as children and didn't find.

Drawing can start to feel consistent, peaceful, and lively rather quickly, even without Plexiglas, if that's what you want. We use the Plexiglas intensively, so that we can stop needing it as soon as possible. Like water wings when swimming. The Plexiglas serves as a learning aid, not as a long-term crutch. The goal is that you will later feel just as sure of yourself when you directly draw a subject on the page.

For me, this was a first experience with really accurate drawing. A very new and very different feeling almost always arises when drawing this way and immediately thereafter. Later in the book, I'll show you how these hand drawings turn into 'real' drawings on paper. Without giving too much away, the drawing on the Plexiglas serves only as an aid with proportions.

'Um, if you show this to everyone, drawing talent won't be special anymore. Traitor!'

Instructions

Get a piece of Plexiglas from the hardware store. (The Plexiglas Picture Plane is one of the learning resources that Betty Edwards spent many years developing; you can find the reference source for the original resources from *Drawing on the Right Side of the Brain®* toward the end of the book recommendations.)

Balance the piece of Plexiglas on your hand, **close one eye, keep your head and hand still,** and 'scan' your hand with a water-soluble, medium-thickness dry erase pen.

Smooth movements, slowly, no sketching or hatching. Follow the contours on the inside as well – don't go around a whole finger, or worse yet, draw an entire 'glove' before filling it in with lines.

Forget about 'hands' and 'fingers'! Just look at the 'weird' shapes and build them one upon the other. **After two or three tries, it'll be going well. In the beginning it can be a bit shaky!**

You're allowed to be amazed. Lay the Plexiglas on a white surface and take a picture. Wipe off the Plexiglas. Repeat often and enjoy.

Always keep one eye closed when doing 3D on 2D drawing! You can tell the kids that it's the 'artist's eye' or the 'one-eyed pirate's eye'. (In case of emergency, an eye patch can sometimes help.)

'I couldn't believe what my hand was doing (drawing).'

A participant without any prior knowledge in one of the first courses in Switzerland in 2013, on the experience of drawing his hand.

Hand positions. Marker (water-soluble, not too thin!) on Plexiglas. The cross hasn't come into the equation yet.

Pen Follows Eye in Slow Motion Above the Subject.
An Introduction to Perception – Not a Long-Term 'Drawing Technique' (!)

Plexiglas exercises also work with other simple subjects.

Don't elaborate on structures and details! The exercise is only meant to enable you to perceive something (often for the first time) as it really is before your eyes. So draw accurately on the Plexiglas, but only the bare essentials. Then you'll be able to see consistent proportions and a consistent perspective, even if everything is a bit shaky.

Here, the Plexiglas was placed directly on the subject.

The Picture Plane (Plexiglas, glass, or plastic wrap on a cardboard frame) – an often misunderstood tool that we use in a targeted way so as to soon be able to leave it aside

When the painters of the Renaissance found out how to bring the 3D world proportionally into 2D, everything suddenly took a tremendous turn toward realism. Projections, as we know them today, were used heavily, even in training. The previous slight awkwardness and flatness disappeared from portraits and other images within a few years. The book *Secret Knowledge: Rediscovering the Lost Techniques of the Old Masters* by David Hockney provides evidence and explains this thesis very vividly. Not all art historians are fans. Whether Hockney is one hundred percent right or not, simply use the possibilities for yourself.

'What nonsense. Hello, anybody can simply trace something.'

You need to experience this. Splurge and get yourself a piece of glass or Plexiglas.

You can also lean it up in a steady position, further away from the subject...

... and now a bit closer, which foreshortens the perspective of the object you're drawing.

Most people are surprised at the result. It provides an inkling of what will later be possible, even without the Plexiglas: drawing 'like the real thing' instead of in an involuntarily symbolic and helplessly simplistic way.
Drawing: Matteo B., age 9.

Try it: <u>Scan contours and 'flat' shapes in slow motion with eye and pen</u>. It's never quite 'perfect' (you're not a photocopy machine!), but it's usually exciting and surprisingly different from what you're used to. Keep your head still and close one eye. The initially shaky feeling soon goes away.

Do grids like this seem familiar to you? Caution:

A grid provides little to no help in the learning process. Why? Because it's experienced and implemented as a crutch, instead of as a training wheel within a learning process. You're more likely to count boxes than to learn to see. Most people that do this give up on observational drawing before they have a real chance to get any pleasure from it.

Yes, I know, Dürer (among others) clearly presented something like this as a permanent tool. But I firmly believe in the emancipation from learning aids (exception: sighting with a pencil).

Subjects viewed through the pane and drawn on the pane. The marker needs to create rather strong lines, not too thin.

Don't have the original Picture Plane? The 'other' feeling of drawing using the eye-pen connection can also be had with a piece of clear plastic or glass from the hardware store.

For the introductory exercises you only need paper, pencil, eraser, and fineliner anyway. If you get curious and seriously want to imitate my entire learning process without improvising, the full original kit of learning materials is still available to order in the US (www.draw-right.com). Before I knew exactly what I would actually learn from it, I found the kit expensive – depending on the package and with shipping from the US, it costs 50 to 150 euros. In hindsight, I have to say: to me it was worth every penny. After all these years of frustration trying different things, going to evening classes, and studying at the university back in the day, it would even be worth ten times as much.

To build my self-esteem as a draughtsman and to overcome my inner bastard, I apparently needed just such a reassuringly structured set of tools and materials. In order to actually be able to learn something, without having to already be good at it.

The subject, the tip of the pen, and your eye are on <u>one</u> axis.

Forget about color and details for now. Use subjects like these because of the 'difficult' but large shapes. Caution: the Plexiglas technique is not suitable for detailed observations or entire landscapes.

As a useful exercise, use peppers under a piece of Plexiglas (this one's from the hardware store).

Draw only the important lines. Choose a marker that isn't too thin, otherwise the drawing won't have the right effect. To archive your drawing, place it on a white surface and take a picture with your phone. Look frequently at the ones that worked and remember the feeling you had while drawing. In this 'other feeling' of drawing lies the key to progress.

I recommend transferring the drawing a couple of times from the glass to a graphite-primed sheet of paper, looking carefully and continuing to draw (lighting is from the top left). It may look something like this (example is with graphite primer, more about this starting on page 100).

Different Learning, Different Feelings, Different Results

Especially for the basic exercises (lines, white triangles, drawing around shapes, upside down observational drawing, blind contour drawing, drawing on Plexiglas), you should practice until <u>you can do them in your sleep</u>. By doing this you will make sure that it feels good and, above all, 'different' than you were used to in drawing before. Even if the last time may have been decades ago.

This 'different feeling' while doing it is the key to progress. Without this key (activation of <u>visuomotor coordination</u> or the right brain or whatever you want to call it), drawing remains mechanical for many people and is rarely experienced as profoundly satisfying.

'(...) Rembrandt has portrayed his eyes as different in alignment, which some recent research suggests might have enhanced his exceptional powers of observation. (...) Harvard researchers have recently suggested that the misalignment might have had the same effect as closing one eye in order to remove binocular vision.'

Betty Edwards, Drawing on the Right Side of the Brain, The Definitive 4th Edition

First With Plexiglas, Then the Same Subject Without It – Surprise Yourself

I've drawn with the picture plane (the pane of Plexiglas) so often that now drawing works much better even without it. For example, in the hotel room looking in the mirror, instead of watching TV. In day to day life there are always gaps for drawing, if you are motivated by your first <u>experiences of success</u>.

Beatrice G., age 13. Drawn freehand <u>after</u> the perception training with the Plexiglas picture plane. The goal is to be able to omit the 'visual aid' – it's <u>not</u> a crutch to be used forever.

Fineliner, done by eye alone. In the mirror of a hotel room. It went amazingly well, perhaps because the subject in the mirror already appeared in 2D.

First Steps With Your Newly Discovered Eye-Pen Connection — Without Plexiglas, from Crumb to Roll and Ever Onward

After doing the line exercises, the upside down observational drawing, the blind contour drawing, and the drawing on the Plexiglas, subjects like these can work well as an <u>intermediate step</u>. They require little conscious handling of perspective and contain few or no shapes that activate the symbol system (such as mouths, eyes, and noses, for example). The more confident you become with these 'small' subjects, the more viable your development as a draughtsman becomes in the run-up to 'larger' subjects.

Breakfast. Slice of bread with butter. I experienced it as a revelation, starting with doable subjects. Practical: after every bite you have a new subject.

Cookies like those here make rewarding subjects when starting out. Each one is a little different! The stereotyped version, without activated visual perception, is easy to spot. Don't go crazy with perspective. If it works, fine, if not, then draw these subjects (at first) from above, almost vertically.

To warm up, briefly do some blind contour drawing or try <u>slowly</u> drawing the edge of a shadow a couple times, as seen above. This gives you a feeling for the rhythm of the contours and shapes. In this image, I've done that twice and then moved the bread so you can see the lines better.

Fancy a whole roll? You can copy the steps here.

The eye explores, the fineliner draws along with it. Every mini-shape is different. This overwhelms the left brain, so it lets the right do its job. You'll notice at once, for example, that it suddenly seems less 'annoying' to draw the small pieces.

Whole grain bread roll, enlarged detail of drawing. One piece is 'built' on to another. Look closely 'with your eye'. Everything is different! Similarly to the white triangles, the next bit is always drawn in relation to the existing ones.

When you realize that every grain and every crumb looks different, you're already well on your way to clearer visual perception.

As with the small scale, so later on with the large: these are contours of bushes, trees and grass. However, I recommend that you start with small, nearby objects, until you feel more confident.

I lightly hatched the shadow and then carefully dissolved it with the water brush.

The shadow was still too light for me...

... so once more with the Fineliner over it.

Finished: the bread roll now seems more three-dimensional. In time you'll find out for yourself what you want to do and how you can achieve it. Don't be afraid of occasional catastrophes; they happen and are part of the process.

Negative Shapes: Draw More Freely Thanks to 'Captive' Spaces

Draw the spaces of photos first. Build one interior negative shape upon the other. Only then draw the outside contours. That's it. With letters like those here, you can train the other way of looking at things as well.

When starting out, count on mild to strong conflicts within your mind. Slow down and build one negative shape on the next until doing it feels 'different'.

First from Suitable Photos (Not Only of Plants, of Course), Then for Real

Observational drawing from photos makes getting started easier and gets the brain used to this particular way of seeing. The question marks in the upper right corner of the drawing show you where I deviated from the negative shapes. A lot of other things are improvised, too. But the overall impression is typical of and demonstrates the principle. Enjoy your training!

I use the fineliner for this because it doesn't allow for corrections. This motivates me to look closer and to proceed very attentively. After a few attempts I got it right. Don't give up!

The idea is not to draw a 'beautiful' finished plant, but rather an achievable excerpt of it.

Start with a single bright shape and slowly add others to it. If you suddenly can't remember which part of the plant you're on, stop and take a deep breath. Then look calmly for your spot on the plant and the drawing. Surprise yourself with what comes of this exercise. Over time, your gaze becomes calmer and it works ever better.

'Negative shapes? But shouldn't we always think postively?'

Photo of a plant. You can clearly see the 'captive' bright negative shapes.

Can you find the right section?

Attention to negative shapes and their relationships to each other – first from 2D (photo) to 2D (drawing), then from 3D (a real subject) to 2D (drawing). Here I've drawn a section of the plant from the photo. For the moment, release yourself from the notion of drawing a plant.

You can also put some leaves down, as shown, and then, using a graphite-primed drawing sheet, draw and erase the bright intervening shapes.

And Then with Real Subjects: Close One Eye and Put One Shape Next to Another, Just like with the Photos – Until the 'Something' Emerges

After just a few attempts, this can lead to an 'aha!' experience and a kind of 'soothing' satisfaction in drawing. Even if it's usually not one hundred percent 'correct', the overall impression (the 'gestalt') is quite convincing.

To understand and train with this principle, look for subjects like this. These are examples of 'real' negative shapes, while the outlines can be seen as corresponding 'negative' outer shapes.

Negative space drawings of a carpet beater (woven from willow branches). Beatrice G., age 13.

Here it's easy to see how an object (the subject is a chair) begins to appear recognizably on the paper by defining and erasing a few well-placed negative shapes.

Different chair, same procedure, now with tonal values and details added in. Beatrice G., age 13.

Once the principle is familiar to you, it can soon be applied to subsequent drawings. Here, the course participant started with a negative shape as a basic unit (for more on basic units see the following pages). Then she defined other negative shapes in relation to it and only then continued to draw the chair 'normally'.

Negative shapes facilitate perception.

Chair in the making. Application of the perception of negative shapes. Naomi K., age 13.

Here I started with the 'captive' shapes and then continued. It felt completely different and went ahead more effortlessly than the usual 'drawing a tree'. On the right, I left the graphite primer in place for illustrative purposes.

Hard to believe, but many people in France have never seen the negative shape in this logo. Can you? (Hint: white letter).

Start With a Basic Unit
Instead of Hoping for Luck

In the past, I didn't spend a second thinking about 'planning'. Drawing was a creative thing. When it worked, I felt talented. When it didn't, untalented. Where a subject landed on a drawing was just a 'matter of feeling'.

I'll show you an almost ridiculously simple procedure (once you've got it), with which you can lay out your composition on the paper. Sighting is well known – but it was Brian Bomeisler who showed me how to use the concept of basic units for laying out the composition. My experience is that when the composition is sorted out, it's much more relaxing to draw and the drawing will be more realistic. Get a viewfinder and look through it often, without 'needing to draw'. Just look and move, until the framing of the image feels right each time.

You can make your own viewfinder (I was too lazy to do this, I must admit, so I used the piece of Plexiglas). To do this, use a boxcutter to cut out a format window in the aspect ratio of your drawing pad from a dark cardboard box.

Use this to determine the image (the framing) and look for something within it to use as a basic unit. Take note of where the basic unit is within the format. By doing this, you've set the composition. The basic unit in the drawing logically determines everything else, since everything is drawn in relation to it.

Choose a basic unit and 'take aim at it' with a vertical stick. Always go from the end of the stick to the thumb. A Starbucks coffee stirring stick happens to be the ideal length, width, and thickness. This is true – whether you like Starbucks or not. Important: don't cut the rounded end off of the stick and make it straight, because then it works very poorly!

The basic unit is the 'starting point' for the orientation of all other relationships. In this way, a subject comes onto the page. Reliably and without stress.

'Could you help me? It doesn't fit.'

72

Look at subjects in this way frequently. Try it yourself, both indoors and out, first without drawing, but with the stick or pencil. At some point it will 'click'.

Keep the basic unit in front of a subject, and you'll see the relative sizes much more clearly. In the beginning you really have to measure. Then try eyeballing it – but keep checking until you're more confident. You'll be amazed at just how far apart seeing and reality are at first. Here, too, proceeding carefully will bring you up the learning curve faster.

What is seen in the subject is represented to scale on the drawing. Not 1:1. By selecting the size of the basic unit on the drawing, you are determining the scale factor.

Stretch out your arm! Otherwise you'll vary the distance and thus the proportions. And always hold the stick or pencil vertically. Think of a virtual, vertical picture plane in front of your face. Like a glass door, if that helps you. This image plane is 2D and corresponds to the drawing paper. In this way, the 3D subject becomes flat – through the extended arm with the stick, you're always 'at the glass door' – and the 'flattened' subject in the drawing thus takes on consistent spatial proportions.

Why Should You Lean the Drawing Pad at an Angle, and Why Did Painters Traditionally Use an Easel?

The most pertinent answer is because of the picture plane (i.e. the 'glass door' upon which you can sight with the stick). If you look out through a small window or gaze through a framed sheet of Plexiglas at your living room, you can see a section of the view as a 'picture'.

As if it were framed, flat, and vertical in front of you. Imagine that you are 'tracing' this 3D subject directly on the window or Plexiglas, or rather through it. It will look right.

The brain has a lot less unnecessary 'translation work' to do if your drawing page is tilted enough and therefore more in line with the vertical picture plane.

How Oblique Lines Make Their Way from the Subject to the Drawing Paper

Using the stick or the pencil, take the angle on the subject, then let the stick or pencil sink or 'fall' at the same angle onto the sloped page. That's a parallel shift! It produces correct drawings in terms of perspective without you having to construct them using projections. When the paper is lying flat on the table, doing this is impossible and perspective in free drawing becomes an extreme headache. (Put simply, perspective is just oblique lines.)

When starting out, you'll tend to unintentionally 'point at the subject' with the stick and things will go awry. Remember that angles are also measured on the imaginary glass door (virtual picture plane) in front of your face.

The stick cannot pass through this glass door, it always has to

stay parallel to your face. But you can relax and let your elbow down and in, because the arm shouldn't be stretched out when determining the angle. Otherwise it's impossible to 'drop' the sighted angle down onto the drawing pad.

Whether chair or house, you can 'drop' the sighted angle in this way – without changing it – onto the page (downwards parallel shift).

MAKE A 'LONG ARM'

↑ STRAIGHT ARM, STRETCH YOUR ELBOW!

The world with the stick in front of it: more clearly recognizable in its proportions.

A drawing pad leaned up at a slope corresponds more closely to the vertical (imaginary) picture plane.

One Subject, Many Options for Framing (Composition)

Here are examples of five sizes and positions of the basic unit (church roof to spire) on the drawing pad (not transferred 1:1 from the subject!). Everything else comes from this. It's as simple as that. Zero magic.

Instructions

You don't always have to fill the entire format – but starting with a basic unit helps you to consciously orient yourself in the scene. Over time, this happens intuitively.

Choose something as a basic unit, for example the height of the church tower with or without the roof. Move your thumb on the stick until the object fits between them. Between the end of the stick and your thumb, you now see the basic unit of your subject.

As you draw, you'll be able to compare and thus better see all ratios within the subject.

Again: Don't Transfer the Basic Unit 1:1 to the Drawing.

As with a city map, this is done to scale. This means that the proportions on the drawing are the same as the proportions of the subject – but on a different scale.

Here are some examples of the positioning and size of the basic unit in the drawing. From these sizes and positions, your composition emerges. If you have learned and internalized this, it can of course be handled very freely. Even 'intuitively' or 'by feeling'.

Subject

Basic unit of the subject

Your hand with the stick or pencil (vertical).

Drawing pad.

First position the basic unit. There are various possibilities for the basic 'roof to spire' unit in the drawing – you decide.

As you can see, the size and position of the basic unit on the paper determine the framing. And through it, the composition as well.

Practice sighting on the computer or TV screen. Imagine that what you see is outdoors. Something like this post can be a basic unit – but only 'one' of them.

Compare everything on the subject with the basic unit.

For example, how many times does it fit here? Without the stick, you'll generally be off by a long shot.

Three and a half times. Thus the front post on the drawing will also be three and a half times as large as the back one.

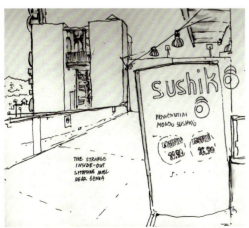

In Genoa. I used to think things like this were 'undrawable'. Today I can see the relationships between elements better and know how to help myself along. Do you see any possible basic units?

Applied Perspective in Everyday Life

This is how the arrow is painted on the street. Some of the lines are more than twice as wide as others. To a pedestrian looking down from above, it looks wrong.

The same arrow viewed at an angle in the direction of travel – that is, fore-shortened in perspective. Now it looks just right. If some of the lines weren't painted much wider, you'd hardly be able to see them from the car.

Learning to See More Clearly with the Magic Wand* – Discovering and Compensating for 'Built-In' Human Misperceptions

If you know something is large, the left brain wants to draw it large. Even if it doesn't actually look large from your vantage point. That's why, for example, seats on chairs (viewed obliquely from the side) tend to be much too large in drawings.

To illustrate this, I drew a zebra crossing for you by looking at it, but without sighting. And then I did it with sighting, that is, in perspective as it really looked from my vantage point.

People often confuse this and say, 'I'll just draw it as it looks like to me.' Or, 'Everyone sees the world differently.' If you're having fun with that and/or are doing it willingly, wonderful. If you aren't doing it willingly and would like to have the choice, use this book.

The eerie phenomenon of unintentionally 'flipping' landscapes, tabletops, seats, zebra crossings, and streets – demystified.

Pavement | Street with zebra crossing | Pavement Hedge

This is the size of the zebra crossing on the picture plane

This is the size of the zebra crossing you 'know' from experience

A zebra crossing from exactly the same viewpoint. The one on the left was drawn spontaneously from the car 'as seen and estimated'. The one on the right was checked with sighting. The reference photo was, as you can see, not taken from the exact same point.

My favorite sighting stick in original size.

Typical misperception with cups, etc. (the left one is exaggerated for clarity). Since we know that the opening is round, we tend to make it too big. Since we know that the bottom stands flat on the table, we make it (too) flat. Here again, the stick helps with the reality check.

Faces Activate Our Stored Bank of Symbols in an Extreme Way. Only Knowledge of Our 'Distorted' Perception and Thorough Sighting Help.

Simulated extreme 'before' drawings

In extreme cases – when a person has stopped drawing in early child-hood – it really can look like this in adulthood. Kissing lips, holes in the nose, tiny ears, eyes that look almost exactly the same from the side or from the front, very thin neck, eyes set high in the head, etc.

Since the upper part of the head, unlike the lower part, provides scarcely any information that was important for survival in human history, we see it as smaller. Above the eyes we see about one third of the head, from the eyes to the chin about two thirds of the head. Drawings made by both children and adults, without guidance in seeing, usually show the eyes toward the top of the head.

Some constants in head proportions. These are not drawing instructions! They are only here to help you notice misperceptions and to invite you to use sighting, until you're able to draw people accurately.

Use the Stick to Ascertain the Position of the Eyes on the Head of Your Fellow Humans.

With a stick or pencil, look (sight) where the ear really is when seen from the side. Is the line between the lips really in the middle between the chin and the nose? To see this, it helps to know a few reference points and to keep a stick up in front of it. Here you can also see the schematic drawing (which reappears on page 116, in the section on portraits). A detailed presentation or an excursus on anatomy would, however, be beyond the scope of this motivational book.

Hold a coffee stick between yourself and the subject and be amazed. Especially when drawing people.

Summary: If you think of the names of the 'parts' when drawing people, you have no chance to produce anything except involuntary 'Picasso pictures'. The dutiful brain draws exactly this: individual parts in symbolic form, stored since childhood. But all the while, the visual intelligence we each possess notices that something just isn't right. If this conflict is not resolved constructively, the typical stress of drawing arises, leading to despair and even extreme rage.

Contours and Other Early Insights

○ I'm able to explain what is meant by contours.

○ I see more interesting contours in everyday life than I used to.

○ I notice more subtleties when drawing contours than I used to.

○ When I draw lines, I sometimes feel like I'm 'on autopilot'.

○ Blind drawing now works almost automatically.

○ I slowly 'drew' the line replication exercises multiple times.

○ When drawing, I hold the pen further back than when writing.

○ When colouring around the figures in the 'colouring book', the white shapes emerge clearly once I've finished.

○ When colouring around the figures in the 'colouring book', I consciously change the pressure and direction.

○ I drew relaxedly and lightly over the lines, then erased them cleanly from within.

○ I 'painted' some figures so darkly that I could no longer make it any darker or increase the contrast further.

○ When I study the contours of my colouring shapes, I no longer see the lines because they've 'disappeared' into the marks from the pencil.

○ I felt a good feeling when one of these figures was finished (even a little one counts).

○ I'm able to explain what the upside-down observational drawing exercise is good for.

○ I've done the upside-down observational drawing(s) several times.

○ In the process, a 'different' feeling of drawing has set in.

○ I'm able to explain the difference between symbolic drawing and perceptive drawing.

○ I used a stick (please no rulers!) for the upside down drawings.

○ Sometimes I drew first by eye and then checked with the stick.

○ With the inverted drawing, I transferred some important points as coordinates from the original to the paper.

○ I've noticed while working on the inverted drawing that making adjustments by erasing (usually gradually) leads to more satisfaction.

○ I've drawn my hand several times by viewing it through a Plexiglas disc or the like and was very satisfied with the result.

Switching to the 'Right Brain', or Seeing-Thinking

○ Switching to the 'right brain', or seeing-thinking, is going well thus far.

○ I'm already familiar with a 'somewhat different' state of consciousness due to long highway rides, daydreaming, jogging, meditating, etc.

○ During the exercises (e.g. lines or colouring), I felt that something was different than with 'normal' drawing.

○ In some exercises, the usual 'drawing stress' is gone.

○ In some exercises, I have a different sense of time, or none at all.

○ I detected some stress at first due to the contradiction between 'measuring' and 'drawing by eye' (in the upside down observational drawing, for example).

○ My self-talk was very critical in the beginning.

○ Now, I almost always manage to consciously direct my self-talk in a helpful direction.

○ If something just doesn't work, I'm able to leave it alone and try again later.

○ When I compare my drawings with those I made previously, they feel more 'talented' or more interesting (even if they may not be 'perfect' yet).

○ I've noticed that my attitude toward drawing and my emotions in drawing have changed significantly.

○ I often manage to 'get into' a drawing quickly.

○ I draw something several times a week, or even daily.

How am I doing?

Outsmart your inner bastard and use this checklist. You can use it over and over again.

Go through the questions (after you've already done the introductory exercises). You can repeat this at intervals to track your learning until everything comes up as 3 or 4.

When that's the case, you're very likely well on your way.

4 = yes
3 = usually
2 = yeah, yeah, whatever
1 = no

An annoying tip: the questions that bother you the most show the way to the thing that will help you the most. No joke.

Negative Shapes:

○ I'm able to explain what so-called negative shapes are.

○ I found it easier over time to see negative shapes.

○ I've drawn something using negative shapes five to ten times.

○ When drawing from negative shapes produces an unusual or rough drawing, I'm able to handle it to some degree.

○ I've taken an intermediate step with suitable photos (easily recognizable negative shapes).

○ I've linearly drawn several real subjects using negative shapes, similar to the simple examples on page 70.

○ I remember to close one eye (if necessary) while drawing.

○ I'm able to explain why this can be so important in drawing.

○ I'm able to dissuade myself quite well from drawing the object directly.

○ I started with a negative shape in the middle and worked my way through shape by shape until the 'subject' became recognizable.

○ I'm amazed at how negative shapes can now be seen everywhere.

○ I'm able to find appropriate, workable subjects for negative drawing exercises.

○ Seeing the result of a negative drawing was suddenly fun.

○ Seeing the result of several negative drawings was suddenly fun.

○ I have the feeling that I see some objects differently than before.

Ratios (Proportions and Perspective)

○ I'm able to explain what a basic unit is in drawing.

○ I understand why some artists put a pencil in front of their faces while drawing.

○ I've compared the visual proportions of near and distant objects around the house with a stick or pencil.

○ I always extend my elbow (arm straight) when I'm sighting ratios.

○ I hold the stick or pencil vertically when sighting.

○ I'm able to notice when I still point forward with the pencil/stick from time to time.

○ When sighting, I work with the distance from my thumb to the tip of the pencil/stick.

○ I can determine the angle of any oblique lines on a subject with the stick or pencil.

○ I can 'drop' this angle of the stick, unchanged, via parallel shift onto the sloped drawing pad.

○ I can explain the picture plane and the purpose it serves in drawing.

○ I know why 3D subjects need to be 'flattened' in order to draw them consistently in 2D.

○ I'm able to explain why it's extremely helpful to keep the drawing pad at an angle.

○ When determining angles, I always hold the stick parallel to my face (on the picture plane!) and thus don't point forward, even on 'steep' lines.

○ I double check the angle I've drawn on the sheet by lowering and raising the stick.

○ I've noticed that a subject can seem to change quite a bit with multiple sightings, but that it can then be drawn more consistently and feels better.

○ I'm able to explain this strange effect to myself.

If unsolvable problems arise, seek help. If needed, contact me by email, even if you haven't yet booked a correspondence course (www.stressfreizeichnen.com). Sometimes there are small (but nasty) misunderstandings that can be sorted out with feedback via photo/email.

A View in Black and White and Colour – Enjoying Success Along the Way

For me personally, what helped was to learn to look carefully, to internalize the five component skills, and to accept the 'cognitive shift'. I also needed some help with understanding the topic of 'seeing and mixing colour'. With colour there are, for instance, misperceptions owing to the phenomenon of 'colour constancy'. If we know that an apple is red and yellow, it takes effort at first to be able to see the many shades thereof.

In short, if you haven't been able to achieve a satisfactory level of drawing, sketching, or painting using other methods, try this 'other' way of learning before giving up completely.

Learning with the same amount of assistance that the Renaissance artists had is encouraging (thanks, for example, to tools like the Plexiglas disc). Getting started requires success that we're able to believe in – especially for adults who have believed in their lack of talent for a lifetime.

Rapid Success with Drawing Your Own Hand – That's Encouraging

With instructions regarding the approach, but drawing everything yourself, step by step. Examples from beginner courses, 2nd day. We also deal with this topic here in the book.

When you get your foot in the door to perception, many things become possible. Helping you to find the door is the purpose of this book.

Germinating potato. Pastel and finger.

Vlada. Pencil and then watercolor. From a photo (as an exception).

Maxim. Quick sketch at home. I wouldn't have even tried this before. Now it succeeds more often not. With sketching, I consider it a success to have a few consistent lines, a consistent impression. Everything doesn't have to 'be perfect', not by a long shot.

One of My Key Experiences: 'Power over Space' through Sighting

Suddenly, I could draw 3D space believably. With helpful strategies, staying at it, and a few tips. On the 3rd day of the course in the US. An incredible feeling, back then.

Live in the zoo: the only animal that would stay still. Fineliner and water brush.

At a Thai restaurant. 'Urban Sketching' seems to be a real trend. For the experts it looks quick and easy. If it doesn't quite work that way for you, then seriously: try it with the five component skills of drawing before you give up, or fail to even start.

Perfectionism kills drawing. The experience of consistency brings happiness. Take small steps and appreciate your slowly growing proficiency.

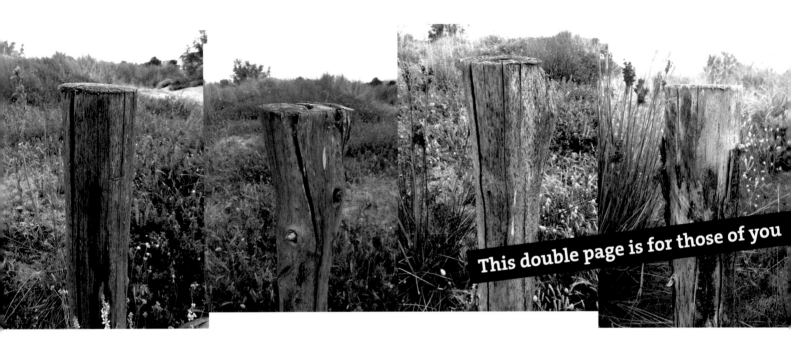

This double page is for those of you

'There is seeing-thinking and speaking-thinking'

Prof. Nanne Meyer

'Intelligence is that which remains hidden from the halfway glance.'

Prof. Nanne Meyer

Seeing in the sense of the 'artist's eye' and learning to draw means that you not only recognize <u>what</u> is in front of your eyes, but that you also increasingly notice <u>how</u> it really looks. The word 'rabbit' abstractly describes all rabbits in the world. So does the drawn symbol for 'rabbit'. It's the same with the posts here: they're all posts, so what? But after you've looked at them for a few seconds, you'll see more and more subtleties and differences. Only when you look in depth does an object really become visually perceptible and therefore accurately drawable.

In school and education, we mainly train our very useful logical, verbal, and abstract intelligence. The well-intentioned attempt to level the field through art education goes over most of our heads, presumably because similarly well-intentioned 'artistic' projects are attempted before the fundamentals of perception (seeing-thinking) and drawing competency are taught.

For children, it must be like running before they've learned to walk. This can generate dissatisfaction and lead to the obvious conclusion that you just aren't that talented. There is a dictatorship of the Expressionist, of formalistic originality, and of the belief in talent to be observed here.

Experience has shown that this is only overcome by the students who hit upon certain fundamentals of visual perception on their own ('drawing talent'). The rest give up. This is also the way it's described in the specialist literature about drawing development in children. With this book, however, I want to help make the 'ABCs' of drawing present, accessible, and above all, exciting for broader circles.

Eight Spanish posts on the beach.

'Rabbits. Hmm. They're all the same... but they look different!'

Polina G., age 13, in the drawing course.

'It turns out there is a huge difference between looking at something and actually perceiving it.'

Dr. Trafton Drew, neuroscientist, University of Utah

'... there are also some right-hemispheric components of speech, such as speech melody or reading between the lines.'

Prof. Onur Güntürkün, University of Bochum

And it's just as true that there are also left-hemispheric components of drawing. Hatching, for example, has strong rhythmic components and is therefore characterized as more left-hemispheric in its pure form. This stands in contrast to things like the modulation of lines and the subtlety of contours. It's always about the interplay between the two hemispheres and not a question of 'which is the better half?'.

'I don't see any rabbits. Leave off with all this intellectual mumbo-jumbo. You read too much.'

83

Your visual intelligence loves the nuances of the visible world. It wants to lose itself in them. For your linguistic intelligence, that's too much work. It withdraws almost immediately when you look intensively at something for a few seconds too long. Four to five seconds are enough. You're seeing more and more.

**The 3-Minute Experiment.
Trust Yourself and Do It Right
Now – <u>Without Drawing</u>.**

Look at your left hand for about 10 seconds
under sufficient light.

Then set a timer for 3 minutes.

Let your eyes wander very slowly along
the lines and surfaces of the items pictured
here, and also through the empty spaces
between them. Do it, even if it seems com-
pletely pointless to you.

After the 3 minutes, raise your hand again
and look at it for at least 20 seconds.

Does your hand look the same as before or
'somehow' <u>different</u>?

Are
You
Looking
Yet,
or
Still
Thinking?

Plant parts. Found near the beach. Only lines and spaces are drawn.

On the first day of vacation. Still very comic-like, but the main thing is to get started. Quality in drawing comes steadily after, bit by bit.

Sometimes you just need to have some faith and keep provoking the 'cognitive shift' into visual mode until it works. To do this, turn your attention to contours, negative shapes, proportions... almost like a reflex. Also to this end: learn the 'five component skills' by heart!

With My Sketchbook in Corsica

Be Nice to Yourself

It's a new beginning. Just by doing the introductory exercises, things will already feel different than they used to. It's the getting started part that's hard, right? So above all, practice starting. How? One way is with the very doable introductory exercises that I've developed for you.

You should also take good photos of your drawings with your smartphone and keep looking back at them. Tweaking the contrast and such is expressly allowed. Play with them!

On your smartphone, you can go wild with editing the photos (and not only by making them look strange with fun filters). For example, you can enhance the contrast. By doing this, you'll see the effects that are possible, get used to them, and soon enough you'll draw with more contrast on the page as well. Here you can see the admittedly painstaking entries in my 2015 Corsica sketchbook.

In Corsica, the first signs of life that emeged from my drawing attempts were the two mussels and the two Corsican knives. I drew them in a small yet fluid and consistent way, with the typical 'seeing-thinking' feeling that you've already come to know if you've done the first exercises.

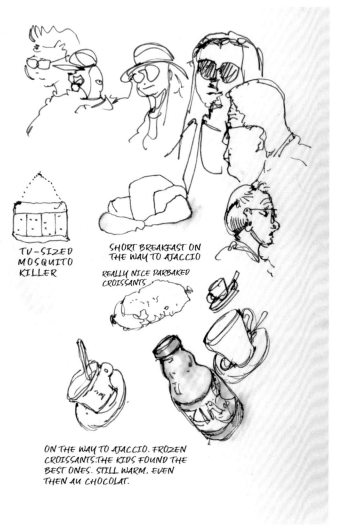

TV-SIZED
MOSQUITO
KILLER

SHORT BREAKFAST ON
THE WAY TO AJACCIO

REALLY NICE PARBAKED
CROISSANTS

ON THE WAY TO AJACCIO. FROZEN
CROISSANTS.THE KIDS FOUND THE
BEST ONES. STILL WARM, EVEN
THEN AU CHOCOLAT.

*In the beginning it takes patience, before it begins
to go smoother.*

FIRST AND LAST BREAKFAST AT THE HOTEL
THERE WERE EVEN EGGS. 27-07-2015 DAVID K.

'Right, hehe. With the way you draw,
you have to convince yourself that it's
good. You can't trick me, you talentless
worm.'

22-7-2015
DAVID K.

FERAL PIGS.
STUFFED IN
THEMSELVES.
SEASONED.
AND SMOKED

AND A HAM HOLDER
WITHOUT HAM.

In Ajaccio. According to the travel guide, the most beautiful market on the island. And I only had time for these few sausages. The time on-site was enough for the shapes. For tonal values and texture, I looked at actual sausages in the hotel.

Lukewarm food is an acceptable price to pay for success on a small drawing. Economical washing with the water brush quickly produces an interesting effect.

'Yeah, yeah. And now you think you're Picasso or something?'

DAVID K.
24-7-2015
POGGIO MAZZANE

Here's the view in the afternoon from the beach restaurant toward the mountains .

Summer 2015: Drawing Every Day for Four Weeks

Sometimes the boss came to have a look and praised the drawings. For the uninitiated, drawing is always magical. Especially if they can recognize something.

During coffee or dinner, you can often draw relatively undisturbed. The family gets used to it. The other guests are busy with the food, the staff with the service. Sometimes they clear subjects from the table, so you have to watch out for that.

What can I leave out, what does the drawing need? Above all, reasonably consistent proportions. I still needed to sight those, so some sizes had to be adjusted. Then came washing with the water brush for some tonal values. The kids had to eat two desserts before Dad finally finished.

View from the table over the northernmost port of the island.

20-7-2015
DAVID K.

While exploring the island. Lunch break. A simple restaurant. Our table was in the middle of the street. That was my vantage point as I drew. Of course, the lamp and the sign at the top were not where they are on the drawing.

Etang de Diana

Geraniums

Well-nourished oysters

Local Muscat

Vin blanc Cap Corse

Poisson

Final resting place on the pasta.

Basta.

22170 *
24.7.2015
DAVID K.

"Very nice.
You should do
that for a living."

In this drawing, I've just gathered some things that caught my interest, without thinking too much about it. Things that were far away are generally toward the top, those further down were closer. Add in some handwriting, why not? The tip of the baguette looked like a dwarf hat.

On this evening, the agreeable server told me I should do this professionally. Maybe she thought that someone who does things like this as a job wouldn't have time to draw in her restaurant. Or that he wouldn't do it in his free time, because he already does it for a living. Sometimes we get the idea that anything that's a lot of fun can't be real work.

'Look here: if you really had talent you'd have been doing this as your profession by now, believe me.'

An evening on one page. There you go. To be on the safe side, I've left the people out.

Tips for Accurate Sketching

'Failure' sounds so final, like you're being graded. When you think of 'misperception', each occurrence is a chance to look more closely and to draw more consistently. Doing this, you'll go far very quickly. The brain believes it and plays along.

Mostly, you find shapes that you can perceive as spaces when you close one eye. These shapes have contours. Start with one that's manageable and, if possible, in the middle of the subject.

From one point on one contour, the eye and pencil can start wandering. Slowly. Only a little bit. If you feel unsure, stop the pencil. Look at the subject. Recapture the secure feeling of knowing where the pencil is (on the subject and on the drawing).

Then look at the subject, move the eye slowly onward, and let the pencil follow. Sit there for a bit, without looking at the paper. Do this until something emerges.

Lines have only directions and lengths. And they can be lively (as in the very first line exercise) or mechanical. The lines create spaces. Which exist in a relationship to each other. And with these things, you're already getting well along.

MORIANI PLAGE
RESTAURANT ON THE FIRST DAY.
GILTHEAD FROM THE TANK INTO
THE OVEN.
19-7-2015
DAVID K.

Time after time, sea dwellers have to sacrifice their lives for the sake of drawing.

There Are No Failures, There Are Only Misperceptions

Just start small. With an A5* or A6* sketchbook, if that feels more discreet and comfortable. If you haven't drawn for a long time, starting itself is a really difficult task. First try it at home with the line exercise, with the upside down observational drawing, or by drawing a few square centimetres of a whole grain roll in slow motion.

Especially at the beginning, always make sure that sample drawings in books you use feel lively and not just 'right' or technically flawless.

'The greatest satisfaction comes from mastering something that is truly difficult.'

Abraham Maslow

*Half letter size (5 1/2 x 8 inches)

*Quarter letter size (5 1/2 x 4 1/4 inches)

SÄGEBARSCH
12-08-2015

'I sometimes think that there's nothing more delightful than drawing.'

Vincent van Gogh

Anyone who has experienced realistic drawing from perception would never consider it to be uncreative copying. It's more like a creative drug.

12-08-2015
SÄGEBARSCH
30MIN 180°C

When you look closely, perches suddenly look like creatures from a horror movie – it's basically just a matter of size. They're caught, they're eaten – here they live on. I've eaten lobster and crayfish before. Since learning to see more clearly when drawing, I'm too much in awe of them and can't do it anymore. Lobsters are said to be able to live more than 100 years, if you let them. Who am I to gobble up such a being in 20 minutes or less? Or these fascinating combers here. Though they were indeed delicious, I must say.

A Strange Jug, Neuroplasticity and Myelinization

I was told in school that as the brain develops, it quickly reaches its maximum number of brain cells and then slowly dies off. Every time you get really drunk, you lose innumerable brain cells. And as the popular saying goes, 'You can't teach an old dog new tricks.' Sounds plausible. But it's completely wrong, by which I mean scientifically refuted. Since about 1890, people have been thinking about this (William James), and since 1948 it's been called neuroplasticity (Jerzy Konorski).

Neuroplasticity — Good to Know If You Don't Want to Accept That You Can't Draw

To their astonishment, researchers discovered (first in songbirds, apparently) that new connections in the brain can form surprisingly quickly. At the remarkable speed of approximately 100 percent growth when learning something new — in half an hour.

Humans, too, can apparently learn new things right into old age. 'Plasticity' means malleability, whereas 'neuro' refers to nerve cells and neuronal connections. This discovery has changed our understanding of learning.

Upon encountering something new, there is a heightened firing of neurons in our right brain. I notice this going on in my head just as little as you do. Experimental results, however, are convincing. Evolutionarily, this ability must be very old, as it occurs even in amphibians.

The old advice 'if you want to increase your creativity, do something every day that you've never done before' thus makes sense from a purely biological standpoint.

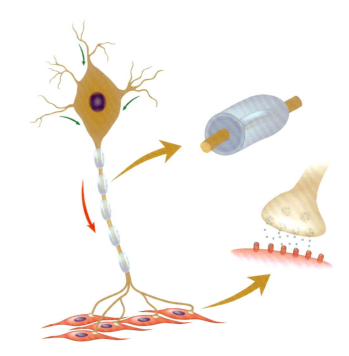

Simplified illustration of a motor neuron. Along the axon, the typical segmented myelin sheaths are visible.

'Come on, nobody believes you, tell them something about talent.'

Teapot in the hotel in Corsica. Not an animal – though it kinda looks like one. Seeing things like this is less a visual habit than a habit of thought.

Cross-sections: multiple myelin layers envelop an axon. The lower picture shows an enlarged view of the layers of coating.

Myelinization – Good to Know If Practising Hasn't Got You Very Far up Until Now

Myelin is a white substance that your brain wraps around its nerve tracts. As you learn, your brain forms new neural pathways (nerve connections) and entire networks of such pathways. Slow, accurate repetition is the best way to strengthen these pathways.

Through these repetitions, myelin layers form around the nerve tracts. These layers are easy to see in pictures. The thicker and more isolated a given path or network is, the faster, clearer, and more automatically retrievable the corresponding action.

If something continuously doesn't work, what you are practising thereby is inability and the feelings associated with it. It's self reinforcing: 'Neurons that fire together, wire together.' (Donald Hebb).

How this relates to drawing: the introductory exercises in this book are deliberately designed to 'automate' important fundamentals if you repeat them often. *This* is the practice that helps to myelinate the desired neural pathways – the more often you do it, the more lasting it will be. Instead of automating failure and anger and giving up, as unfortunately so often happens. As it was with me for the many years I spent 'practising'.

Experts say that after about 21 days, a new behaviour becomes a habit. This also applies to being able to perceive and draw things differently. For this purpose, small units, repeated as often as possible, are sufficient. The new neuronal network in the brain will be present and sufficiently reinforced (i.e. myelinized) after a few weeks.

The more often something is repeated, the more myelin layers form around the required nerve tracts. In sports this is already basic knowledge, while in drawing it's still 'secret knowledge' – because so-called practising is the exact opposite of clean repetitions, at least for beginners.

This much is clear: our culture, which has been in love with the idea of talent and genius for over 500 years, will not give up old opinions overnight because of a few conclusive research results and their confirmation in practice. However, if you're willing to learn from up to date insights – even just as a little experiment, for all I care – then you can find new access to drawing almost overnight. And you can even uncover access to your own, perhaps buried, artistic development.

Here, the dark areas let the light come into their own – this produces a whole.

At the edge of the forest. Without graphite primer. On closer inspection, this sketch is based almost solely on light and darkness. Here, as well, the bright parts are often given their shape by the dark areas.

Important Commercial Break On the Topic of Tonal Values

A first tip on tonal values was given to me by a university lecturer in Wuppertal, to whom I was able to show my portfolio in 1987. His name was Mr. Kafka and he thought that I had a lot of creative ideas and that I should definitely continue in this direction. He let me know, however, that with the quality of my portfolio (which I now recognize was full of unsure, pale drawings), an application at the University of Wuppertal would be completely pointless at that time.

Then he showed me how to achieve the effect of one tree appearing closer to the front and another being further back – simply by drawing the front one darker. The man was obviously some kind of drawing god and could do magic. Today I know what to look for: how does the light fall, which areas are light, which are in shadow, and where are the transitions? The other question is, which grey tone on the scale from white to black do these things actually have? Especially in the light and in shadows.

I didn't get here <u>all on my own</u>. You?
The secret of light, dark, and everything in between.

Experience has shown that you don't see the actual tonal values at all when you're still inexperienced with drawing.

An etching from 1645: De Omvaal. What we would now call a local recreation area. Today, the tallest building in Amsterdam stands there, the Rembrandt Tower, at 135 meters. Note the way Rembrandt omits the light areas and how he depicts leaves using vivid shortcuts.

A Lemon Is Not Always Lighter Than a Tomato. Even a White Egg Can Appear Dark Grey – Light Can Change a Lot.

It's therefore crucial for success that you first understand the logic of light and, secondly, that you have the serenity in drawing to be able to see tonal values as they actually are. As if you were looking at a black and white photo. By the way, I strongly recommend black and white photos as a perception exercise – they allow you to see levels of brightness without distracting colours. Try it out. They're very helpful – photos such as this one, taken with an iPhone. Very occasionally, it's also okay to draw from the photo directly – but please only for the training in grey values.

All examples on this page (except for the pretzel) are made without a graphite primer. The graphite primer is extremely helpful in learning, but won't serve you well in the long run as a drawing technique or stylistic device. For me, however, it was an extreme learning accelerator.

When you draw with pencil on light paper, the lighter an area is, the emptier you leave it. In other words, you draw the light by not drawing it. Got it? If not, it's best to first learn tonal values and light using the graphite primer.

This is a drawing by Rembrandt van Rijn. That man could see, unbelievable. You can learn a lot by trying to see and understand how he depicted what he perceived with lines, shortcuts, and tonal values.

It was Albrecht Rissler with his book Zeichnen in der Natur ('Drawing in Nature') that made me aware of the amazing drawings of Rembrandt. They inspired him even as a child. And now they inspire me, a little later. Thanks! If you're interested in drawing beyond the city, gift Rissler's book to yourself for your next birthday, at the latest.

'You could've drawn me with tonal values too, that's mean. I feel so flat.'

Learn Easier With a Graphite Primer: the Eraser Makes Things Brighter, the Pencil Makes Them Darker

Applying a Graphite Primer

Outline a format on a drawing pad with a 2B pencil (A thin piece of cardboard with the desired dimensions works well for this).

Round off the long edge of the graphite stick and then drag it up and down over the format, with medium pressure. Do this several times, slightly <u>over the desired size</u>, until enough graphite is on the paper. To get familiar with this process, prepare three sheets: one with as much graphite as possible, the next one with a medium amount, and the last with very little graphite – these are three well-invested sheets of paper!

Use a Kleenex and one or two fingertips to rub the graphite <u>into the small recesses</u> of the paper in <u>smallish</u>, fairly slow motions.

Rapid rubbing back and forth doesn't do much, as you only smudge the graphite superficially. For it to work, it has to get <u>into</u> the recesses.

Apply it a little beyond the desired format. As a final step, erase from the outside to get clean edges. For this you should use the cardboard or another erasing guide.

This preparation helps get you in the mood for working visually, by the way, as it stimulates the sense of touch. You can use it as a little ritual to create a quiet, focused, drawing mood, once you've got the hang of the technique.

The preparation is the same for every format: Apply graphite with the long <u>edge</u> of a 4B or 6B stick in generous and gentle movements, with light pressure. Keep trying until it works. Then rub it into the paper with a Kleenex and one or two fingers: small movements with a little pressure. It'll never be one hundred percent even, but that's okay.

Typical problems starting out (which I also had):

» <u>Before</u> rubbing it in, is the graphite primer extremely irregular with small spots, or are there dark streaks? Double check if you've accidentally dragged the <u>flat</u> side of the graphite stick over the paper.

» You have to use an <u>edge</u> of the stick, which you round off beforehand on a piece of paper. Or, it may be that the paper isn't lying softly on the rest of the pad. Perhaps you used a single sheet and the surface underneath it is coming through as a pattern. In this case, lay a few sheets of printer paper (or whatever) under it.

» Is the graphite primer extremely spotty <u>after</u> rubbing? Try to apply more even pressure, if you've already checked that whatever is under the paper isn't what's showing through.

» Is the graphite primer very light, and perhaps irregular? Then you didn't apply enough graphite in the first step, and/or you rubbed it too superficially with too little pressure. It works better with one or two fingers than with the whole hand.

'A painter should begin every canvas with a wash of black, because all things in nature are dark except where exposed by the light.'

Leonardo da Vinci

Tone scale on graphite-primed paper. With additional basic shapes under lighting.

It's best to wipe away the debris from erasing with a draughtsman's brush like this one. If done with the hand, it quickly smudges. When finished, treat your drawing with fixative spray or attach a covering sheet (stick it to an edge of the paper with sellotape).

◄ *If the graphite primer looks like the one on the left, you should drag the stick more evenly over the paper. Go a little over the desired size and then erase the edges clean from the outside.*

If it looks like the picture on the right, apply more graphite to the paper. A lot more. It may also be that your graphite stick is too hard. It works well with 3B to 6B. Rub the graphite with short, overlapping movements until the surface becomes an even silvery-gray.

With graphite primer and eraser you can create tonal values like never before. Take a look at the 'eraser samples' and try it out to get familiar with it.

Your Own Hand – On a Plexiglas 'Window' and Then With Graphite Primer

Transfer the linear drawing on the Plexiglas disc (proportioning aid) 1:1 onto the graphite-primed paper. This isn't a problem if you've practised with the upside-down drawing and the basic 'copying lines' and 'creating white triangles' excercises.

After transferring it over, all the important proportions are in place and you can calmly look at your hand and draw what you see with the eraser and pencil. The exciting thing is that the longer and 'less stressed' you allow yourself to look at it, the more you'll see.

Dramatic lighting from the top left helps. This makes it easier to look in more detail – the proportions are already there. Perceiving the bright spaces and areas is usually easier than seeing a 'hand'.

From the left: draw your hand on the Plexiglas. Transfer it to the paper. 'See' the bright areas with the eraser.

The eraser draws light, the pencil dark – you perceive, instead of already 'knowing' everything.

My hand, 2012 – eraser and pencil on graphite-primed paper.

An ideal situation for this practice(!) drawing: 'dramatic' lighting from the top left for clear light-dark contrasts on the hand. Drawing pad fixed in place with tape. Eraser on the pencil for quick switching between drawing with the eraser and the pencil. And a hand position that's easy to maintain for a long time.

Discover a new playground for the possibilities of eraser and pencil.

Your actual hand is the subject. Keep working on the bright areas with the eraser. Then draw in dark areas of the hand with the pencil.

You can also do it this way: very dark primer, lightly erased bright areas, pencil. Here, the graphite primer was not erased, otherwise the hand would have appeared too dark. Drawing by an adult course participant.

Detail of the drawing below.

With patience and the right approach, age seems to play little role. Naomi K., age 13.

First a trial run, without drawing: take proportions from a stone lying directly on the page using the stick. Width vs. height, etc. Try it out.

Lay some stones on the page and draw them. ▶

Bringing simple stones to life can be a lot of fun. Who'd have thought?

Magic With Graphite Primer – Discover More Possibilities

Stones lay still, waiting until something eventually 'clicks' and you realize that the stone on the page is actually a good illusion of the real thing. Before I discovered sighting for myself, I was usually a bit uncertain about the proportions – and therefore lacked the basis for everything else. The result back then: stress in drawing and waning desire.

I strongly recommend that you train with relatively simple subjects like these. Preferably with a graphite primer. Until you have it down pat. Then you can expand your comfort zone with more complex subjects. Proportions include the layout of the patterns on the stones, when this is done seriously. And once the proportions are there, it's fun to find ways to also depict the subtleties and structures accurately.

2.3 START WITH THE HEIGHT

① HEIGHT

③ WIDTH

⑤ FROM THE LEFT TO THE HIGHEST POINT

MARK ON THE STICK!

Indicate a length on the stick. Then you'll be able to compare everything else with it.

The position of the patterns shouldn't be 'guessed at' either, but should be properly measured with a stick or pencil. This example is for illustration only: this is how the first step of a stone drawing would look without the graphite primer.

1. Getting ready to tackle it: have everything ready. Medium-tooth paper.

2. Apply graphite onto the paper with an edge, not with a flat side or corner.

3. Rub graphite deep into the tiny recesses of the paper with a tissue. No lighter than this, otherwise it's like a pencil drawing without the benefits of the graphite primer.

4. Determine proportions. Lightly draw in the important information. Then erase the bright areas and draw the dark ones.

5. Look at the stone frequently as you go. Don't get bogged down with details. Light is erased, dark is drawn.

6. Remove the background and check the contrast, examine the details. Use cheap pencil cap erasers or normal erasers (cut them, if you like).

7. Darken the shadows and dark tones, if necessary, and erase the background to your liking.

By Erasing Bright Intermediate Shapes (and by Darkening Elsewhere),
Black Stones Appear – Training That 'Like Real' Feeling

Look for very dark or black stones like these, 2 to 7 cm (0.79 to 2.75 in.) across.

Prepare a dark to very dark graphite-primed format, at least A5* size, and erase the edges cleanly.

Arrange the stones flat on a white sheet of paper in front of you. Leave only as much space between stones as is shown in the example. Use a similar number of stones.

Breathe deeply. Look at the example on the top left. Pay attention to the light intervening shapes and erase them, as shown – not striving for perfection, but with a consistent alignment, exactly like with the 'white triangles' (basic exercise seen earlier).

On the left, you can see the procedure from top to bottom. Work a little here, a little there, rather than making one area perfect. Let the drawing develop. This happens automatically when you use this strategy of working with the light intermediate shapes first, and if you spend time calmly looking at the stones with 'soft eyes', not worrying about the result. Give yourself a chance to 'allow the stones to emerge' – this is a specialty of right brain mode.

Your visual intelligence, aka visuo-motor coordination, will take care of everything if the drawing strategy is right. You could simplistically phrase it this way: eye steers hand – hand moves pencil – drawing comes together.

** Half letter size (5 1/2 x 8 inches)*

106

On the right hand side of my demo drawing you can see a tone scale. In the middle is the unchanged graphite primer as the midtone. In principle, it's like drawing on coloured paper, only easier.

With Dark Intermediate Shapes (and Erasing the Light Shapes), White Stones Appear.

Look for light or white stones like these, 2 to 7 cm (0.79 to 2.75 in.) across.

Prepare a dark to very dark graphite-primed format, at least A5* size, and erase the edges cleanly.

Arrange the stones flat on a dark or black sheet of paper in front of you. Leave only as much space between stones as is shown in the example.

Breathe deeply. Look at the example on the top left (light arrow). Pay attention to the dark intervening shapes and bring them out with the pencil, as shown – not striving for perfection, but with a consistent alignment, exactly like with the 'white triangles' (basic exercise seen earlier).

Here on the left you can see the procedure from top to bottom, as before. Work a little here, a little

there, rather than focusing on one area. Let the drawing 'come out'. This happens automatically when you use this strategy of working with the dark intermediate shapes and the light stone shapes first, and if you spend time calmly looking at the stones with 'soft eyes', not worrying about the result.

*Half letter size (5 1/2 x 8 inches)

107

Birch pieces. They seem simple, but require attention to relationships and to the characteristic details. ▶

Object studies: wood texture, brush hair texture, fur texture.

For comparison, here's the little bear using mostly the eraser.

Preparation for smaller subjects. A usable graphite-primed area on an approximately A4 drawing pad looks something like this.*

More with Graphite

Even surface patterns (see the piece of wood) and textures (see the teddy) are easier to recreate with graphite-primed paper. You can 'free' the subject from the background by erasing, as is done in sculpture. And the structure of the subject is generally easier too.

First determine the proportions. Then erase the light areas. After this, work with a pencil 'against' these light areas. Continue to erase, rub with your finger, and so on, until the subject looks finished.

** American letter-size paper (8 1/2 x 11 inches)*

Practice drawing by Naomi K., age 13 (eraser and pencil on graphite primer).

Based on a first negative shape, the other 'white' shapes in this practice drawing of a small child's chair were determined by eye and by periodic checks through sighting.

The first negative shape is highlighted here for illustrative purposes. ▶

It often takes several attempts (see the visible corrections to the chair back and seat) before the brain allows itself to substitute <u>preconceptions</u> with visual perceptions, replacing them with the proportions that are actually before you. It often seems when drawing that the chair has mysteriously 'changed' itself, as you carefully sight and draw certain of its ratios three or four times before it finally looks right.

Duration: about three hours of deep learning. With pauses each time a 'funny feeling' arose when comparing the subject with the drawing. Through sighting, the reason for the discrepancy was discovered, the misperception was overcome, and <u>only then</u> did the process continue.

Here above, where the chair back has been erased, you can clearly see the incremental adjustment of the drawing to the subject. Where something looked 'funny', the artist continued sighting and adjusting until it looked right. This takes a really long time at first. But it quickly leads to genuine learning progress.

✷ = Step by step adjustment (with curiosity and sighting!) has a tremendous learning effect. Yet it can only be 'harvested' with a certain amount of patience.

A gnawed pinecone, which laid for a long time undrawn in the studio. It was always too complicated for me. One day, I got up some courage and went at it step by step, like participants in the drawing course do with their practice drawings from the third day on.

Bone study with pencil and various erasers on a graphite primer.

As I drew, I realized that I imagined bones differently 'in my head'. Considerably simpler in shape. This is probably because of all the pirate flags I drew as a child, with (logically symbolically simplified) bones. Most of the time, I still determine proportions with the stick, other than for very quick sketches.

Bamboo root .

◄ Hatch grayscales like this often. It helps you to see and draw effective contrasts.

Sometimes Knowledge Doesn't Help

With something like this root, the only thing that helps is to calmly observe it. It looked really complicated. When I managed to consciously see and draw the dark areas between the little lower roots as small dark spaces, it went ahead with surprisingly little 'brain strain'. I left the graphite primer in place here, so that the light effect would work better. This is a good preliminary exercise for drawing landscapes.

This is the lay of the land in front of the studio. Keep at it, stay calm, compare everything with the basic unit. Then amazing things can happen.

The white arrow in the drawing shows you the basic unit that my daughter used as a 'starting point'.

Aside from motivation, the approach is almost everything: A practice drawing by our then-13-year-old daughter in the week-long course – created 'only' with sighting, not constructed with vanishing points.

My first landscape since early youth. A new beginning. I was very surprised. Drawn from the car (drawing pad on the steering wheel). With sighting, eraser, and pencil.

My basic unit was the tree a little to the right of the centre.

29-5-14 DK

Sometimes Knowledge Helps with Perception – But It's Not a Substitute for It

The basic features or proportions are relatively simple, since they're basically constant in all humans. There are in-depth books on the proportions of the human head. It gets complicated when the view is not directly from the front or from the side. Here it helps to know how to see, and above all to use sighting, if you don't want to memorize complete anatomical conceptualizations.

Some basic, almost unchanging relationships of the human head. Knowing them helps limit the 'brain strain' when drawing heads and encourages sighting.

Learning to see is easier than memorizing.
My opinion.

Be nice to yourself. Symbols tend to be persistent. If you encounter problems, remember to use sighting and draw what something looks like, rather than what it is (mouth, nose, ear, eye, etc.).

My self-portrait here is from elementary school.

It generally works better than before, but it's still nerve-wracking. Self-portrait in the mirror as a quick demonstration in the drawing course.

Ask someone to sit down for you. Look, with the stick in front of you, for longer than normal at the relationships and proportions of the face. Only look at first.

Check the Following Statements On a Real Face

From the front: The eyes are in the middle of the skull. Another eye fits between the eyes. The line between the lips is one third of the distance from nose to chin. The corners of the mouth are under the pupils. The nostrils are under the inner corners of the eyes. The ears are a great deal longer than you'd think.

From the side: The eye is further back than you thought. The distance from eye to chin is the same as that of the eye to up behind the ear. The distance from eye to chin is the same as the ear to the top of the skull (imagine the hair isn't there when you are sighting, if necessary). You can see very little of the eye. The line of the mouth goes downward slightly. The ear is slanted.

An experience: seeing faces differently. Don't draw yet – just look and **be amazed**

Ask someone to stand 1 to 1.5 metres away and look straight at you.

Look between their eyes. Say off the cuff whether the eyes are further up or down in the head, or if they're in the middle.

Move both eyes quickly back and forth from ear to ear 5-7 times, 'scanning' the face without zeroing in on anything. Do it again from crown to chin, up and down.

Circle the outline of the head clockwise with your eyes three times. Then three times counterclockwise.

Close your eyes for a moment. Open them up and look between the person's eyes.

Immediately say if something about the position of the eyes 'feels' like it's changed or if they seem to have moved upward or downward in the head.

This is also exciting from the side. Sometimes your perception of the position of the ear or of the parts covered in hair changes enormously. By the way, how much of the total width of the head in profile do the facial features occupy? (Tip of the nose to the edge of the eye).

Tomke H., self-portrait during the 5-day course in 2015. It took four hours – that's why these portraits often look so serious.

Gregor F., self-portrait during the 5-day course in 2015. Even those who can already draw well usually experience a surprise with tonal values and contrasts.

Portraits Using Graphite Primer Sharpen the Eye For What Is Essential

With strong contrasts through targeted lighting (a lamp shining from top left on the face) and a graphite primer, you are setting yourself up for more success than in a bright room with a hard pencil on paper. If you're well underway with everything else, try a self-portrait in the mirror. Be forgiving with yourself – in art history, self-portraits are traditionally considered one of the most difficult things you can do. It works best with a small mirror attached to the wall. Sit at arm's length in front of it.

On a side note, if you look at a face long enough the 'other' way, it loses its 'meaning' and dissolves into areas and tonal values – just like any other subject.

Portraits evoke the strongest conflicts between 'knowing' and perceiving. I try to pretend as if it's just any old subject. It's not easy, but with sighting it's more doable than without.

The procedure: choose a basic unit on the face, 'front of the eye to corner of the mouth' for example, or 'ala of the nose down to the chin'. Mark the basic unit on the drawing. Then 'chart' everything in relation to it on a flat plane using a stick or pencil. Only when there are enough carefully sighted proportions on the paper should you move on to erasing and drawing.

Demonstration showing the step-by-step process of drawing (from a course). A participant from the side, with sighting.

I would like to show you a learning technique here too,

not only drawing techniques!

An orderly procedure (with a basic unit, etc.) helps you to achieve similarity to the subject more and more often.

Hatching – With Pencil, Fineliner, Pen & Ink

Try out the possibilities. Here I used a very soft Prismacolor Ebony pencil. You can create different levels of grey either by applying a different number of layers at the same pressure, or by applying one layer at a time with different levels of pressure. This is a dogmatic issue among draughtsmen. But you should know both ways.

The brain is more likely to believe hatching that is relatively uniform and dense and which goes to the edge of tonal surfaces. This is why the white ball doesn't work as well. The same applies to irregular and 'transparent' hatching with large spaces between lines.

Picture on the right from the top: Tone scale with increasing and decreasing pressure. Tone scale generated by applying several layers with the same pressure. Tonal gradient with increasing and decreasing pressure. An attempt to produce nine tonal values. On the right, expanding and narrowing lines – keep trying until it works well.

'Senselessly' trying things is worth it.

Highly recommended for imitation at home!

Hatching with pencil: tomatoes, ostrich egg.

Hatching and tonal values with fineliner.

Once you've adjusted to a loose grip, it's 'a lot' easier on the hand.

Waiting scene. Tonal values can also be simplified by hatching in this way. It's best to draw hatching lines diagonally. Horizontal or vertical hatching can be irritating to look at. Test it out. Hatch up to or slightly over the edge, otherwise it quickly starts to look like beginner's work.

Deeper engagement with seemingly simple subjects will get you further, faster than will possible frustration with complex ones.

A pen & ink style popular in the US is creating tonal values through dots rather than hatching. This is really a matter of taste as far as I'm concerned, but I'll show it for the sake of completeness. It can work really well for some subjects.

For additional practice using these 'dashes' (properly referred to as 'hatching'), I've made two drawings from photos (motorcycles) – which I seldom do. Instead of a fineliner, I tried a Rotring ArtPen here. This is more or less like the fountain pens they use to teach penmanship at school, only more expensive. This type of drawing is called the 'pen & ink' technique.

Motorcycles with 'Rotring ArtPen extra fine'.

Progress with the Two Extremes

OYSTER, VARIOUS VIEWPOINTS

Meaningless is meaningful – never underestimate pure contour drawing.

Drawing Slower Than You'd Think

Short review: let's return to the subject of contour drawing without looking at the paper, or so-called 'blind' or 'pure' contour drawing. It's well suited for awakening the 'artist's stroke'. <u>Your task is to make it feel as if the pen were directly on the object, moving in sync with the eye is as it slowly wanders along it</u>. I'm repeating myself – but maybe you skipped past that part earlier in the book.

The gaze that you awaken by slowing down begins to see details very differently. This then carries over into 'correctly' drawn subjects.

Only the process counts: pure or blind contour drawing with 'rich' little items – <u>without</u> looking at the page!

'In order to gain access to the subdominant visual, perceptual R-mode of the brain, it is necessary to present the brain with a job that the verbal, analytic L-mode will turn down.'

Betty Edwards, *Drawing on the Right Side of the Brain®*, The Definitive 4th Edition

'The right hemisphere is a mighty parallel processor, in many ways superior to any computer.'

Iain McGilchrist in *The Master and His Emissary: The Divided Brain and the Making of the Western World*

'Linking' eye and pen for lively lines

This works ideally with organic subjects.

It's worthwhile to experience the 'meaningless'. When once awakened, the eye-hand connection will always be helpful (except of course with technical drawings). Like here with this plant part, together with awareness of proportions.

Drawing Quicker Than You'd Think – Gesture Drawing

There is a type of drawing that goes faster than you'd (speaking-)think: so-called gestural drawing. Give it a try. It doesn't have to be 'right' or perfect. It does need to be rather quick though: drawing as a 'sensory' movement – as opposed to constructed, thinking drawing. While standing, draw loosely on fairly large paper, including big movements from the shoulder. Invigorating effects on small-format sketching are a likely result.

I highly recommend gestural drawing. It's about a spontaneous reaction or the 'feeling' inherent in a subject, not drawing 'realistically'.

The best information on this topic can be found directly at the source, in the classic book *The Natural Way to Draw*, by Kimon Nicolaïdes. Strikingly similar excercises have appeared in many drawing books that came out after it, continuing to this day.

Gestural drawing is a great way to experience how control and letting go are able to supplement each other when you know both. For example, when it comes to speed – faster drawing has more to do with gesture and spontaneity, whereas slower is more about visual representation and control. Speed and rhythm play a large role in drawing.

When learning, you're allowed to – indeed should – exaggerate.

Pears as a gestural drawing

These real-life pears (not drawn from a photo) were the 'subject' for the gestural pear studies.

'Do not fear mistakes. There are none.'
Miles Davis

4th day of the first course in New York. A nice young Asian man who always kept moving. The first drawing I'd ever made in which dark was actually dark with some gentle pressure from the instructor. Never before had a drawing felt so good, I was very surprised and happy with it. Time: about 4 hours.

Learning Slowly Actually Goes Faster – Notes from My Introductory Phase in 2012

Attention: this section is not about chairs, faces, buildings, or interior spaces. It's about conscious experience and cognition, about which ways of thinking and perceiving lead to drawing ability. This process takes time at first – see the indicated drawing times, which are sometimes very long. I find that the process has nothing to do with practice, at first. It has everything to do with learning.

That I can draw rooms, if I have 3 hours to spare, is something I discovered during the first course in the US. But could I also do it with landscapes, and at a higher speed? Drawn from the car in about 40 minutes.

After the third course, practice drawing. Chair set up high, from a very close distance; about 40 minutes.

David Kidar 2-12-12

125

David K, 18-12-2012

▶ *Even before the first course in the USA, I buckled down, sat on the balcony, and drew. Obediently following a book and using a graphite primer. With a slight headache from sighting. There were strong conflicts within my mind: it wasn't easy to see space as flat. I gave up in despair trying to understand the window on the right. But I just kept looking and plugging away at it. And then it worked. I was very surprised because it wasn't a feeling I was very familiar with yet. The brain does actually switch from constructing/understanding to seeing what's around you – to visual raw data, so to speak. As you can see, the trees in the background were still far beyond my reach. I had to leave them out, feeling overwhelmed.*
Time: about 4.5 hours.

Practice drawing, learning about 'sighting'. 3rd day, second course in the US. 'Power over space!' Perspective without projections! I mean it – only with sighting. I found it brilliant, using the coffee stick for this. Sighting with the left hand, drawing with the right.
Time: about 4 hours.

Built up with negative shapes and sighting, then polished with light and dark tones.

Following the 2nd course in the US, I added on one day of sketching class. While making this drawing, my brain suddenly accepted the notion of sighting angles and shifting them downward in parallel to the page, without irritation. A real 'aha!' experience. 'Now you get it,' the instructor said. Since then it's been automatic.

Sitting very close to the subject. I learned more this way.

Look at Drawings and Try to Recognize the
Implementation of the Five Component Skills

Develop a Curious and Analytical Gaze

If there are drawings you like, especially those by true masters, try to understand how they work. Don't just accept that 'they' can do something that is eternally out of reach for you.

On the journey to great skill, practising is indeed required – but try to practise the right things.

Above all, don't under any circumstances practice continuous failure. If it's not working, seek competent help from teachers who don't believe that talent is above all, who believe instead in the conscious learning of perception – ideally in individual steps.

Do you remember where you've seen this before?

Split Coconut on the Table – My Approach

Pencil. Important proportions carefully determined with the stick. One step after another: height vs width, width of the white border, proportions of the visible outer shell underneath. Completely different from what I first thought!

I looked carefully at all the contours and slowly recreated what I saw, determining the direction of the fibers with the stick held at the appropriate angle. Not every single one – but some of them, for orientation. I observed the tonal values of the spaces in relation to each other and laid them in with the pencil.

Where necessary, I erased to make it brighter again. Eyes narrowed, contrasts further intensified, done. My first coconut. Try it too, when you're ready.

Open fireplace with Anjo and a sofa.

Detail of a tree drawing. Can you immediately 'feel' where the attention was focused?

If your subconscious mind knows what you want to learn, it will help you a great deal. To this end, learn the five component skills <u>by heart</u>, today.

Plant shadow, traced with fineliner.

Back to Sketching: Hold On a Sec

Corsica, VLADA.
Planning the day
23-7-2015
DAVID K.

For this drawing, I asked my wife not to move for a bit.

Trips can be planned. But drawings and sketches? Yep, those too. Slowly and consciously at first. With time, more spontaneously, without actively thinking about it.

Since reaching the point where I'm usually able to calmly look at the subject while sketching, rather than 'impressionistically' faking my way through it all the time, I've been having a lot more fun again. And insulting the Impressionists less, I hope.

The page on the right is there to show you a different way to approach 'realistic vs. kinda-ish'. I sketched the lamp, kettle, and bottle twice, quite quickly. I was a lot more satisfied with the proportions the second time. This only works if your eyes stay mostly on the subject.

'I'm ignoring this for now.'

'You've got it, it's divine!'

Our wonderful, rather elderly figure drawing instructor during my university days, when someone quickly and perfectly hit the line between form and lively expression. The subject was a mother with a baby in her arms. At that time I had only a vague idea of what she meant. Today I suspect she was talking about direct visual perception and the resulting spontaneous 'gestalt effect' on the page.

Another approach to 'realistic vs. kinda-ish'.

This scene was several tables away. Through simplification, it transformed into a mixture of observation and exaggerated shapes in my mind. I thought, all right then. I'll just make it into a caricature. Something different for a change.

'In drawing, the moment you think you know something, you're in trouble.'

Brian Bomeisler, artist, workshop leader, son of Betty Edwards

During the summer holidays I was usually the first out onto the hotel terrace, coffee and sketchpad in hand.

THE RESERVED TABLE WAS UP FRONT

WE WERE HERE

OMELETTE NORVEGIENNE

AND ON IT GOES:
LA VALLICELLA
28-7-2015
DAVID K.

DAME BLANCHE

Especially during holidays with the family, the opportunity to draw presents itself before, during and after meals. You're already sitting anyway, and everyone is busy.

Oil lamps in the hotel. A huge collection. I found them great for training because they're similar and yet still different from each other.

Learning to draw liberates your artistic self-confidence and makes the creativity within you more accessible. Even if you think you don't have any.

Something in Me Is Amazed Every Time a Drawing More or Less Works Out

'To think creatively, we must be able to look afresh at what we normally take for granted.'

George Kneller in *The Art and Science of Creativity*

It seems as if the time taken to complete a drawing stays hiding there within it. Photos, on the other hand, all take about the same amount of time, more or less. The brainwave patterns during deep drawing, by the way, can be similar to those of experienced meditators. It would make sense, then, that all concept of time would be lost while drawing perceptually, and that a strange feeling of happiness would often ensue, as is so often reported. This happens to me a lot when drawing. But if you only hear it from me, you might think I'm losing it. Who knows?

Snapshots. Quickly capturing (flat) shapes. Experience has shown that even a little bit of success can be addictive.

My approach with the drawing below: the basic unit was the left edge of the house, between the awning and the roof. I marked them in a reasonable size on the drawing. Then I built on to them, gradually determining the essential relationships. Vegetation like this is always an exercise in omission. How much does it take to make something 'discernible' as a whole? Do you see the small negative shapes in the bushes, and the size difference between the beach grass at the front, in the middle, and behind? The vegetation wasn't especially bright. It almost never is. Have you noticed that? The drawing takes life from the delicate way the lines are drawn and the minimalist implication.

Our hotel on the beach.

ROAD FROM POGGIO MEZZANA TO THE
CASTAGNICCIA, RETURN TRIP FROM BERBA

29-7-2015
DAVID K.

FRIES?⇨

I found it particularly difficult to adapt the size of the abstracted plants to the distance. This is important for the spatial effect, however. The view of the small forest road was captivating. In the mountains above the Costa Verde, drawn from the car.

'We used to draw when traveling to remember where we were. Today we film while traveling to discover where we've been.'

Albert Camus

Here again, my goal was to avoid being overwhelmed by the vastness of the scene and to find lively shortcuts for the complicated plants.

A mountain village above the Costa Verde.

To draw every leaf would take years. With sighted proportions, deliberate omission, and lively abstractions, it thankfully went a lot quicker. That the mountain peak hits the edge of the picture is a problem with composition. It happened like that because I just went ahead with drawing the foreground without first planning the framing on the page.

The Wider View

Landscape studies are overwhelming at first. For me it's very helpful to start from a basic unit (for example, the height of an object somewhere in the middle) and then to establish the ratios by comparison through sighting. I try to capture the details with shortcuts. It's crucial when doing this that they maintain their liveliness, or in other words that are not drawn mechanically, all in the same way.

Landscape. Corsica is really good at holding still, but has a lot of details.

Urban sketching, a little differently: this is what's left of the Roman city after more than 2000 years.

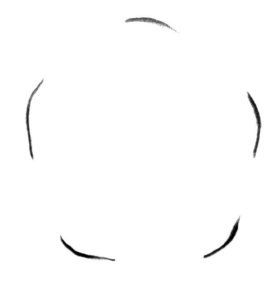

Set an apple on the apple-shaped area and look at it for ten seconds. Does anything stand out to you?

Be curious and open-minded and pay attention to what happens (do it with other fruit and organic items that fit here as well). The more naturally and irregularly coloured the apple, the better.

Put This Book Somewhere in Your Home Where You'll See It Frequently

It's intentionally designed so that you'll always be able to find something when you look inside. Seemingly at random. Not like with a normal textbook.

This way, your seeing-thinking will have a good chance of being activated. Seeing-thinking and what we call intuition or gut feeling, by the way, are very much related.

'Everyone has the intelligence necessary for drawing, but few want to go to the trouble of opening their eyes.'

Jean Joseph Jacotot

Do you know this quote, or ones like it? I had already opened my eyes, but saw almost nothing — until experiencing the switch to 'seeing-thinking', accepting it, and then training with it.

How to Keep Your Drawing from Going Pear-Shaped

These pears are quite irregular. A bit of twig has been left in for pure contour drawing. You could also use something else. The important thing is to have similarly interesting organic shapes.

I've included here again, in a compact format, the four individual learning goals, which are also well suited for enabling the 'switch' to visual mode.

1. Perceiving the Subtleties of Edge Lines or Contours

Take a drawing pad and a sharpened 3B pencil and turn away so you can't see the paper. Take a piece of pear branch in your hand and look at it from really close up for a few seconds.

Then let your eyes continue to very slowly make their way along the subject — and this time, move the pencil on the paper in sync with your eyes. You are experiencing, without looking at the paper, pure contour drawing. What you're actually doing is drawing your eye movements. Another way to think about it is that you're scanning the object with the pencil, then attentively drawing the 'scan' on the paper. It's going to look like 'scribbling', that's okay. Try it. The line itself looks pretty lively though, don't you think? Many artists do this to get 'in the mood'.

The pear harvest from our garden in 2015.

Valuable 'learning scribbles': super-slow contour drawing without looking at the paper.

2. Perceiving Spatial Shapes or Negative Shapes

Negative/spatial shapes aren't prevalent in this subject, but you can still find them. Look between the stems and leaves. These 'empty' shapes are referred to as 'negative shapes'. They produce the shapes of objects ('positive shapes') by means of their inverse – like it used to be with film development. In other words, they share outlines with the normal shapes and cause these to appear. The brain has no ready-made symbols for spatial shapes, so you're able to see them more accurately. Which imparts confidence very quickly.

A famous example of the effect of negative shapes. Landor Associates 1994. Do you see the arrow? (Once you've seen it, it's im-possible to unsee.) This is not the official Arabic FedEx logo, but it is a good example of gestalt recognition. It instantly brings FedEx to mind, doesn't it?

Imagine that the top image here was your subject. Follow in your mind's eye what I show you through the drawings below. You can transfer this basic unit to the drawing as an 'initial size' that determines the composition. With it, you can compare and draw everything to scale. Even 'angles' can be seen better this way than with unarmed eyes.

3. Perceiving Relationships (With Sighting)

Imagine that you have a pane of glass in front of you at the same distance as your outstretched arm. You can 'measure' the subject on it as if it were a flat projection on the glass, right? If you keep your arm stretched out with a fully extended elbow and hold the stick vertically, it's like a real pane of glass (the picture plane!). You transfer this virtual flat 'image' – starting from a selected basic unit – onto the drawing pad.

The procedure:

try sighting the height/thickness of the pear and compare how many times it fits within its length. The measuring range always goes from the end of the stick to the thumb. The horizontal pear is thus about 1 and 2/3 times as tall at its tallest point as it is at the point where I'm currently holding the stick. Mark the shapes with short strokes. If possible, make these markings such that they suggest the shape. (Not too dark!)

You can see the angles of the contours more clearly if you bring the stick into line with them (not on the 'glass pane', but further back and parallel to it, with a relaxed elbow!). The stick now has an inclination (angle). Apply this inclination precisely to the corresponding line on the drawing. To do this, bring the stick from the subject to the drawing via parallel shift.

This works best when the drawing pad is not flat, but is resting on a sloped drawing board or leaning up against the table.

Select a basic unit within the subject. Stretched out arm, vertical stick!

4. Perceiving Light and Dark

You can best perceive light and dark when you take a black and white photo. It's also helpful to make a tone scale, from the tone of the paper to the darkest tone the pencil can produce (hence the use of soft pencils, at least 6B). The gradations should be even, like steps on a staircase.

To test darks without risk to the drawing, draw a spot on a piece of paper, folding it backward through the centre of the spot. Then hold this gray value up to the drawing and see if it works for you.

Ensure good lighting, optimally from above and to the left. Little or no light from other directions. Light background. Look at the whole for a while. Squint your eyes, so as to see areas of light and shadow more clearly and be better able to separate them. The relationships of the light and shadow areas can also be easily determined with the stick.

This is how this subject might look with tonal values on the drawing. From time to time, make yourself a tone scale right on the drawing. This is training! Tonal values can also be compared, just as sizes can. The line drawing above the pears illustrates once more the process of sighting.

Le VOLLE MARINE, POGGIO, KORSIKA
Le POOL. 24-7-2015 DAVID K.

With fineliner in 'pen & ink' style, so without washing. With this method, you can 'only' create light and dark through layers of hatching. It's fun. But it takes a while. It's important to pay close attention to proportions (use sighting!) and to clarity of shapes and deliberate omissions. Also notice the background with the minimal hints of vegetation. Try it on another page until you like it.

A fineliner a look around has.
On vacation he nothing but time has

Did you linger on the heading because something about it was a little odd? If you read it slowly a couple of times, what is the feeling you get? Different from what you get with normal word order? Holding the stick in front of a subject works similarly for things of a visual nature. It's a small irritation that awakens the brain's 'other' awareness, because something is new and unfamiliar. It's an evolutionarily proven mechanism – even in amphibians, a new feedworm triggers measurably increased activity in the right brain. It may therefore be helpful when drawing to look at things as if you've never seen them before.

Here I was interested in whether I could manage, in terms of drawing, to tame the large flowering bushes with the fineliner. Maybe less would have been more. You have to find things like this out for yourself through doing and constructive self-criticism. Comparisons with other people's drawings – those you find to be good – can also help a lot. I now get less annoyed by little mishaps (one of the legs here looks a bit strange) than I did at the beginning.

24-7-15 DAVID K.
LEVOLLE MARINE
BANANA AND
PALM FROM
THE POOL SOFA.
FELT LIKE 45°C
IN THE SHADE.
OR STRELITZIA.
WHATEVER.

THIS IS WHAT
IT LOOKS LIKE
WHEN I SWAP
BACKGROUND
AND FOREGROUND

The fineliner was at work here again, without use of the water brush. The parrot beak plant in the pot at the top of the drawing was, of course, standing on the ground. On the lower half of the page, I've drawn the view from the table over a wall onto some palm trees and deck chairs by the pool. It's a two-part drawing. I'm allowed to do that – it is, after all, my sketchpad. You should take liberties too.

MORIANI AT NOON
BOR DI MARE. THE ONE WITH THE
THIN PIZZA DOUGH AND SPONTANEOUS
ENGLISH SPEAKING.

29·7·2015
DAVIDK.

Beach restaurant, elevated two meters and bordering directly on the sand. Meal with the family. First, the view of the remnants of the food, which are fascinating upon closer inspection, then of the figures swimming on the beach. And lastly, a view from above on stones in the sand and a sunbathing woman. It always amazes me how intensely a scene appears in your mind's eye years later when you've invested a few stokes in drawing it.

You Can Do Anything That's Fun – Enlarging, for Example

It can be a new and surprising experience to draw on a small to very small scale with the fineliner (which you'll be able to do relatively consistently after some time with the basic exercises), then to take a picture of the drawing and enlarge it on the screen. Or to make a print for yourself.

'If you didn't draw it, you didn't see it', the saying goes. When you start drawing, you'll quickly realize what this means. Drawing seems to intensify your perception (not only visually) and to keep memories of what you've seen and encountered vivid.

SCULPTURE,
DEEP FRIED.

Unforgettable

Observations on a plaza in Bastia, Corsica. Can you find the legs of this incredible pigeon?

You'll Gradually Pull Off Increasingly Complex Subjects – with Less and Less Brain Strain

With subjects like the swimming area with the stones or similarly complicated scenes, it helps to draw one object after another with 'soft eyes' (see the 'upside down drawing' and 'white triangles'). In this case, a stone in relation to the existing ones in the drawing. If you get too deep into a single stone, the relationship to the others soon derails (Remember the white triangles).

The Amount of Time it Takes to Drink a Coffee

Quickly choose your framing for the picture, determine a basic unit, and get started. It may work out, but doesn't (!) have to. For me, slow drawing is figuratively speaking like 'training', and faster drawing is more like 'competition'. There's never a one hundred percent success rate. Even experienced artists usually throw away most of their quick drawings. I find that reassuring.

'Geez, just take a picture like a normal person.'

One of the famous Corsican river swimming areas.

Only I can see here the incredible colour of the bay and feel again the heat and the wind. Drawing can do that.

SOLENZARA
AT THE RIVER. 31 KM
TO ALERIA ON THE RIGHT.

23-7-15 DAVID K.

WATER IS HERE.
NOT SO SUITED
FOR THE FINELINER.

GOLF AND THE BEACH. THEN
THE WRONG WAY FROM BONIFACIO.
PROPER PIRATE BAR.
28-7-2015
DAVID K.

Too Much 'Left Mode' Is Frustrating

Again: too much 'measuring', perfectionism, and thinking about 'correctness' usually leads in the long run to a technical, uninspiring, and even off-putting feeling and overall experience.

The result on the page is often rather stiff, and you feel emotionally distanced from it. If, that is, you can keep going at all and don't give up in anger.

It can end up feeling like soulless 'copying' of the subject, and that is something perceived and judged by many to be 'creativity-killing'. This is a scenario that I understand very well.

Tomatoes, free-drawn. Shape by shape, without thinking about '3D curves'! A good subject for training your ability to see shapes two-dimensionally. At the very beginning they're also an ideal subject for drawing under the diagonally resting piece of Plexiglas. Just like peppers.

Irregularities promote looking – which makes these tomatoes ideal subjects.

Too Much 'Right-Mode' Is Just as Frustrating

If right-brain mode is activated (in inexperienced draughtsmen) before the proportions of a subject are correctly determined and marked, it leads (in my experience and that of my students) to angry despair with the task after just a few strokes, as you realize that the drawing has little to do with the subject.

It can't be said often enough:
Recognize the pitfalls of 'belief in talent' that stand in the way of your learning.

A Short Side Note on Drawing Stress

I think that this 'drawing stress' is most likely comparable to the reaction of a gifted child who is prematurely required to read a whole text, but who is still struggling to read the words properly or who has not yet internalized the process of reading. If this child now thinks that something is wrong with him, and compares himself to older children who can already read effortlessly, it doesn't lead to anything good. When learning to read at school, it's with good reason that children are spared from such experiences, but when drawing – either alone or at school – almost every child is confronted with them.

In my drawing classes, I observe this frequently in adults who gave up on drawing against their will as children, hurt and frustrated. Some remember feeling angry, or even enraged.

At this stage, every 'restriction' placed on them through instructions on drawing strategy has to be done with a great deal of empathy. Success through small steps is the most helpful thing: re-creating lines, causing white triangles to appear, drawing small, complex subjects upside down, etc.

This is complemented by rational and logically comprehensible references to learning and training methods that we know from competitive sports. It's my assumption that this is what makes it acceptable to engage in the learning process at all, instead of these students just 'giving it a go to see if they're good at it'.

What does motor boating have to do with drawing? Know-how helps with both. It's helpful, for example, to actually throw out the anchor instead of thinking too much about it. Before the boat runs aground, preferably. Luckily, it happened on an almost deserted stretch of beach. We needed professional help to get that powerful monster back in the water – exactly like what can happen with learning to draw.

There and Back Again on the Ferry – So Soon

▶ *The kids on the ferry at six o'clock in the morning. It seems that hands were especially difficult to draw around this time.*

BASTIA. THE EARLY FERRY TO SAVOGNA!
01-8-2015
DAVID K.

A line, a traffic jam. Drawing is creating illusions, not copying.

DAVID K.
01.08.2015
LIFEBOAT.

On the deck, the wind was so strong that just standing was difficult.

DAVID.K
01-08-2015
BASTIA, - SAVOGNA.
THE 'COSY BAR' AT 7:00

01. 08. 2015 DAVID K.
GABBRUCHES
RETTUNGSBOOT.

*Lifeboat. My excuse is that
it was really stormy.*

Mooring lines in front of the window.

SEIL AM RETTUNGSBOOT
04.08.2015.
DAVID K.

Expect strangers to come up and talk to you and comment on your drawings as if they've known you for years. Always amazing, this effect. But nice.

DAVID K.
01.08.2015
POOL BAR

A couple sleeping on the deck, foreshortened in perspective.

I try to be happy about every successful little line. The kids in their comfort zone on board.

07-08-2015 DAVID K.
BASTIA - SAVOGNA, THE CABINE

Only on Vacation or Forever?

At home, old habits are closer to hand. If not drawing has been a habit for decades, a new one is going to be needed. I don't manage to do it every day just yet. However, not a day goes by – hardly even an hour – in which I don't see differently than I used to, and if drawing doesn't end up happening, I now get a strange feeling that the day was missing something. Sometimes I notice my hand moving along with my eyes as they wander over something.

Commuter ferry on Lake Zurich. Here I felt like drawing a small head on the man. So I did.

'And what exactly does all of this get you, all this drawing?'

VIEW FROM THE BALCONY

MALVA

'OUR' BIRCH IN THE GARD FÄLLANDE STRASSE

IT WORKS AT HOME TOO...

DRIED SEEDED CHIVE BLOSSOMS.

02-08-2015 DAVID K.

ROSE

THISTLE ON THE BALCONY

SECOND LAST DAY OF SUMMER HOLIDAY.
ZURICH. WITH THE KIDS. VLADA. & DIANA.
A MAN WITH A VERY LONG NECK.
SCOOTER OPPOSITE. PRETZEL WITH PUMPKIN SEEDS.
 BREZELKÖNIG
15-08-2015 STADELHOFEN.

Small things, also a beginning. A pretzel such as this is ideal for awakening your ability to see.

People are always exciting. But only once I've had a chance to look at them calmly.

Free-roaming chickens. Small child. Quick impressions are sometimes great too.

Seemingly trivial things sometimes give me the most pleasure.

Kirche in Weisslingen
11·1·2014
DAVID KADER

Church on a hill, drawn outdoors. With purposeful sighting, a lot of things are possible more quickly than you'd think. This is an example of a rather powerful, quick stroke style, but still with enough calm to let me take the proportions and the angles of the building lines to the horizontal (informal perspective).

Bei Weisslingen, Nebelstimmung

11-1-2014
DAVID KADER

Mist effect, drawn outdoors. An attempt to capture this moment with pencil and eraser (but without graphite primer). Here I've chosen a completely different drawing style to enable me to get at the subject artistically.

At the outdoor pool. Copmosition is whatever you happen to like. That isn't a typo
– only the overall impression counts. First, very mindfully uncover your natural feel-
ing for composition. Using a 'viewfinder' has proven useful for this. A rectangular
hole cut into a dark piece of cardboard works. A piece of Plexiglas with a frame on it
is also fine. Or, with some practice, you can use a 'picture frame' that you make with
your fingers in front of your face. In time, you'll be able to estimate the position of
the basic unit and bring it, true to scale, onto the page. The more experience you
acquire, the more intuitive composition will become. It still doesn't always work
out, but more and more often.

► Outside in nature, meditatively
drawn. The graphite-primed paper
makes it easier to avoid so-called
'active', accentuated lines. In the
repeated alternation between
drawing with the eraser, drawing
with the pencil, blurring with the
finger, and above all, looking at
the subject and sighting the rela-
tionships, where necessary, a
rather painterly result unfolds that
is untypical for drawing. Of course,
not everybody likes this style. If you
do, everything you need to achieve
it can be found in this book.

Training Your Perception in One Square Metre –
the Hotel Breakfast

Seeing Contours

Draw in super slow motion. Look for a point and stare at it 'too long'. Imagine, in the process, that the pencil is scanning the subject. This helps to shut down 'speaking-thinking'.

In the pure form of this exercise, nothing recognizable should come from it (don't look at the drawing sheet and keep at it for about 15 minutes).

When the connection between eye and pen feels natural, you can occasionally look at the sheet to capture the overall shape as well.

Prop the book up so that this page is well sloped and the text is horizontal (pile a few books underneath). Then try to imagine that this is a real hotel breakfast. Try to reconstruct how I would have looked at it. With selective perception, this is extremely helpful at first in overcoming the normal overwhelmed feeling.

I hope that you'll try it again with a real breakfast at home. The key is to stare at it for a few seconds 'too long', then to draw very slowly and, above all, to keep looking at the subject. When learning, it's less a matter of working with a 'beautiful' subject than it is about focused perception and that 'other' way of looking, 'seeing-thinking'.

I can't, by the way, recommend that you draw from photos. First of all, the subject is already flat, and secondly, you see it with a stranger's eyes if you didn't take the photo yourself. I had this same breakfast a couple of times, and I photographed it myself. I can thus kind of halfway work with it. You should take a real photo of your own and use it for very slow exercises. The more irregular, organic details are present, the better.

Perceiving Spatial Shapes (Negative Shapes)

This can be done with a fineliner or a soft, sharpened pencil. In practice, people usually alternate between negative and positive shapes. They have the same contours, after all.

Do you remember the exercise with the black pies, where the missing pieces made up the white 'triangles'? If you're still having trouble with negative shapes, please read the instructions toward the front of the book and do this exercise. And you should also repeat the gestalt exercises with the triangles, etc. – keep at them until they're almost effortless.

Seeing Relationships (Proportions and Perspective)

I messed up on the height of the vase. Prevent this by checking with your stick or pencil on the photo. Find a way, even if it doesn't look perfect.

Here I'm looking at how many basic units there are from the top edge of the bread rolls to the bottom edge of the vase.

Angle of the table edge, shifted in parallel onto the drawing. This works better with a relaxed, bent elbow.

To sight angles, bring the stick and the angle in line with each other (always parallel to your eyes or your line of sight, not 'pointing backward'). Follow that with a parallel shift down onto the propped up drawing.

The height of the upper roll in the basket: How many times does the basic unit fit here?

An angle taken from the plate to the left of the bread roll. Shift it in parallel onto the drawing.

Compare the size of each element of the subject with the selected basic unit (only one!) and take note of the size ratio (never mark on the stick when sighting!). These measurements could be, for example, 'about 1/3 of a basic unit', 'a basic unit and a little more than 2/3', 'almost 2× the basic unit'... this isn't micrometer accurate, but it's accurate enough. Always compare one size at a time with the basic unit and transfer it to scale onto the drawing.

How do you draw to scale again? Like this: if your basic unit (one!) is the height of the topmost bread roll, compare that with the knife (sight with your arm outstretched) and take note of how many times the basic unit fits onto the knife (twice and a little more, in this case).

The basic unit – in our case, the height of the topmost bread roll – is set as 'one' in the scale of the drawing. You apply it to drawing the knife in the marked ratio, in this case 'a little more than 2 × the basic unit'. And then you continue like that. Never transfer sizes 1:1 from the subject to the drawing!

If you've got a handle on shapes and negative shapes – and preferably also on proportions – you'll be able to make faster progress with tonal values.

Seeing Tonal Values

More pressure or multiple layers of hatching? It's a matter of taste and practice. Try it out.

Upper row (left): 6B, increasing pressure.
Bottom row: 2B, each square with one additional layer of hatching
Right: 6B and 2B pencil, exercise in varying the pressure with smooth transitions. Give it a try.
Don't give up just yet! It'll come.

Even when 'only' using lines, you can still draw very well. But the image here gives you an idea of how important tonal values are for the 'gestalt', i.e. for the 'like real' effect.

After all, lines don't really exist 'out there', we make them up when drawing. Make tone scales like this often. The more confidence you achieve with shapes and proportions, the more clearly you'll be able to see tonal values.

Comfort Zones, van Gogh, and Little Successes

My father listening to a Christmas oratorio.

Did you know that van Gogh had to fight hard to become confident at drawing? In one of his letters, he describes how he's made a major breakthrough with a book called *L'Alphabet du Dessin* ('The ABCs of Drawing'), by Armand Cassagne.

One of the most important tools mentioned in this book is a viewfinder. Van Gogh went so far as to build a wooden frame for determining proportions outdoors – and he wasn't ashamed of it. The modern version of this is a Plexiglas disc, like the ones I became familiar with as a temporary aid in understanding 'flat vision', or in other words, the picture plane.

Van Gogh as a role model? As far as learning to draw is concerned, I think he's ideal. He developed himself into one of the greats, but previous to that, he withdrew from the academy and taught himself to perceive intensely on his own – drawing wasn't handed to him on a silver platter.

Van Gogh intensively used 'visual aids' in learning, and also to a degree in painting. For example, he made use of a viewfinder with a sort of crosshair. But even so, nothing about his work looks mechanically 'copied'. Its expressiveness is astounding.

I am convinced that his paintings are so impressive precisely <u>because</u> van Gogh had also managed to get proportions and perspective sufficiently under control. From his letters, the conclusion can be drawn with near certainty: he wouldn't have produced any paintings otherwise.

'Drawing is as easy to learn – even for children – as are reading and writing (…)'

From Armand Cassagne's *L'Alphabet du Dessin* ('The ABCs of Drawing')

Stretch your comfort zone. It's alright if you fail every now and then. But also regularly choose subjects that allow you to have those important experiences of success.

Sunflowers become more interesting to me when they aren't completely fresh anymore.

Drawing among tourists, very exhausting.

Sometimes almost nothing works. That makes me sad. But a day later, I usually see some manageable line or shape or another.

I remember when making this drawing that the longer I looked, the more light and shadow effects there were to see. Almost spooky, this effect.

The man is so-so. But the woman's head looked exactly like this. I could already feel that as I was looking at her and 'roughing in' the drawing. Almost as clear a feeling as with the white triangles in the introductory exercise.

The Zen of Drawing?

If you're willing to follow the logic that the word 'religion' comes from the Latin word religare, which among other things has the meaning of 'reconnecting', then you'd have a possible explanation for the quality of the feelings that are so often described by drawing artists.

Strong activity in the right hemisphere by diminishing the dominance of the left hemisphere can be experienced as the feeling of 'being one', of being 'connected to everything'. So say the professionals. There were even experiments in which non-believing test subjects reported strong religious experiences.

To me that sounds a lot like the experiences that practiced meditators describe. If that interests you, it may be worth getting to the bottom of it.

Personally, I find it striking how well many of my observations regarding drawing (and beyond!) fit the hypothesis of the division of tasks of the brain hemispheres. At least as far as my research could uncover, the principle behind this hypothesis has been undisputed since Roger Sperry's investigations, which were rewarded with a shared Nobel Prize. Even if open questions still remain. A fact that is probably due to the nature of the thing being studied, since the brain has to be its own research subject.

Abstract tree? Meditating pencil? One evening in the studio, while the students were working at a long task on their own, I had a rather large sheet of paper in front of me, and after an hour I had this. I remember just starting somewhere without thinking about anything. After an hour, this drawing appeared, as if on autopilot.

This is where most of this book came into being.

172

'(...) paradoxically, the more clearly you can perceive and draw what you see in the external world, the more clearly the viewer can see you, and the more you can know about yourself. Drawing becomes a metaphor for the artist.'

Betty Edwards, *Drawing on the Right Side of the Brain*®, The Definitive 4th Edition

An unknown something that washed up on the beach in Corsica. I can't explain it, but this is one of my favourite drawings.

In my week-long courses, I have seen many times how experienced bankers and successful entrepreneurs have danced for joy as they made their own advances in drawing. No joke. It's alright to be happy from time to time, I think. And I recommend it to you too. After all, almost all of us were plenty sad as children when drawing was so 'impossible', at least beyond the usual level for our age.

An oyster shell. Pencil. The partly illuminated interior can only be represented in contrast with the dark areas.

'(...) and suddenly you realize that you are not looking at the actual pot in front of you, but at a mental representation of a pot, a generic image – a stereotype.'

Buddhist geshe Michael Roach (paraphrased). Of course, he doesn't know anything about my soup pots.

This isn't limited to drawing: we always see a symbol. And this symbol likes to push its way into the drawing (speaking-thinking). You're familiar with the effect and have experienced how you can trigger seeing-thinking – by quietly looking at something longer than normal.

Soup pots at a Japanese restaurant. Constructed solely using tonal values. I remember being very surprised at how 'automatically' it worked.

Did I mention that I am shamelessly proud of this originally rather small drawing?

The secret? Do your basic training and look forward
to everything to come.

Text within the illustration:
CHESTNUT BEER
CERVEZA DE CASTAGNA
BIERA CORSA
Pietra
BIÈRE
75cl.
alc. 6% vol.
LDEN RIVER
Tawny
PORTO
ORIGIN BOTTLED
1000 CURVES. MAXIM THREW UP
IN THE SAND RIGHT NEXT TO THE
RESTAURANT
THAT
EVENING.
PRETTY
COOL
CAP CORSE
MUSCAT DU CAPCO
APPELLATION D'ORIGINE
Vin Doux Nature
19% vol.
PORT
16%
CAP CORSE
DEPUIS
1872
L.N. MATTEI
100cl
16-08-2015

Sometimes, from small beginnings, a whole page of observations comes out.

► *There are some traps to be avoided when first drawing cars. I'm continually amazed, for example, at how large tires really are. Sometimes they take up almost half the height of the car. As a kid, I probably drew tires a lot smaller. For this and all other misperceptions, the only thing that helps is to sight with a stick or a pencil.*

CARS ...
ALMOST.

CUTE LITTLE JAPANESE (?)
DELIVERY TRUCK WITH
EYES

4-08-2015
NSTER. WAITING FOR MAXIM AFTER THE TRAINING CAMP.

Onlooker. They usually hold nice and still in profile. You can also just capture key essentials with the pencil. That's what I did with the withered and defoliated rose.

'You have to keep right on drawing, all the time; draw with your eyes when you can't draw with a pencil.'

Jean-Auguste-Dominique Ingres

Perhaps what Ingres means by this is: 'use the "artist's eye", that different and precise mode of looking, as often as possible.' In other words, switch to seeing-thinking.

'Every drawing is useful and drawing everything is too'

Adolph Menzel

I recommend the splendid book *Radically Real*, which was published in connection with an Adolph Menzel exhibition. He was probably the best 'urban sketcher' of the 19th century. He drew constantly, mostly in pencil. Including while looking out the window and in the carriage. He drew the mud on the road, and hair in a comb, and mummified officers in their tombs, and in general anything he encountered that caught his eye — but he's known to most as a painter of great oil paintings. He was a very small man and at the same time one of the greatest among draughtsmen. You can get facsimile editions of some of his sketchbooks in second-hand bookshops.

Some of the finds from the beach that you've previously seen as linear drawings. This in-depth observation with the pencil can be very satisfying. In my personal experience, at any rate.

Mallow stalk with flowers, in front of bushes. In former times, I wouldn't have even dreamed that I could pull something like this off. The difference for me was the way of thinking, not 'drawing technique'.

Don't forget feedback.

For real

It took me a while to be able to see how dark aubergines really are.

For real

Small study, pineapple with perception errors.

A piece of eraser with holes in it. Everything suddenly becomes interesting when 'the other awareness' of the right hemisphere gets involved.

Toes. Homage to Adolph Menzel. For me, he is the 'eye' of the 19th century and a great inspiration.

Sprouting organic potatoes that had survived in the studio for an incredible one and a half years. Non-organic relatives had rotted in a few months.

Old man in the countryside.

179

Summer Sketches 2016

Tree panorama in the nature reserve on the shores of Lake Thun, near Interlaken. On the right is part of the fairway at the eco-friendly golf course.

◀ Subjects used as a warm-up at the start of a drawing week in the Bernese Oberland, in Switzerland. Most of the drawings are in a DIN A5* sketchbook, with HB, 4B and 8B pencils. Here, a tree stump by the Lombach river, near Unterseen.

A look into the forest. First attempt. Perceiving and re-creating negative shapes ('dark areas') makes it easier for me to switch to 'drawing vision', instead of having trunks and branches in my head while drawing.

* Half letter size
(5 1/2 x 8 inches)

181

Studies in the Weissenau nature reserve. The birds there have little fear of humans.

Drawn while sitting on the trunk.

FALLEN GIANT, LAKE THUN
WEISSENAU NATURE RESERVE

View across the waters of the broad Aare river into the forest on the other shore. Strong late afternoon sun from the left. In this drawing, the shapes emerge primarily through the reasonably consistent drawing of the 'non-shapes'. Fortunately, the fast-flowing river is pale turquoise due to the mineral content and thus there are no difficult reflections of the forest to be seen. Lower down among the bushes, a few bright spots are the only thing that gives an idea of the path of the riverbank.

The proper roasting of traditional brain sausages (colloquially known as cervelat) is a custom in Switzerland. To do this, you need a brook, river pebbles for the fire pit, dead wood from the forest, hazel shoots for the sticks, and a Swiss army knife. Drawing utensils are optional, to taste. The burning fire was still too challenging for me.

01
08
16

◀ At the top of the Grimsel Pass. If you cross the tree line, you won't have to grapple with drawing trees, as the name implies. Other challenges arise instead.

I made these two drawings with graphite primer as a transition, so I could bring the feeling that was familiar to me from drawing smaller subjects into the stunning high mountain world.

RAINY DAY

Rainy day in the holiday rental. It takes more than that to stop my pencil.

Near the Sustenpass. If you've captured your composition and proportions on site and the time runs out, you can continue to draw textures – as well as light and dark tones – at home using photos (taken from the same perspective). The low bush implied at the bottom of the picture is first laid out as a shape.

Our children Maxim and Naomi help with comprehending the proportions of the mountain landscape at the Sustenpass. In the foreground is one of the typical rocks ground down by the once mighty glacier.

06
08
16

These boulders still hint at the power of the landslide that came to rest here long ago. Steep alpine meadow above Lake Thun.

The Lauterbrunnen valley with one of its waterfalls.
Irresistible for basejumpers.

◄ At Interlaken. Part of
the Harderwand, as
seen from the Lombach
river. Graphite marks
like those above and to
the right can be avoided
with a separator sheet
or fixative spray.

$\frac{04}{08}$
16

LAUTERBRUNNEN VALLEY

Withered fruit tree far above Lake Thun.

View of the exposed old road leading from Beatenberg to Thun.

LAKE THUN

06
08
16

This is how a completed sketchbook page can look. From a series at a swimming beach in central Switzerland. On DIN A4. Drawing small and quickly can work very well with time.*

** American letter-size paper (8 1/2 x 11 inches)*

Drawing at the Pool Is Always a Little Nerve Wracking

The courage to get out the sketchbook is great... but if courage alone doesn't work for you, try getting started with the basics of perception (the five component skills of drawing). Just a little tip after 35 years of frustration.

The legs of a bread man (in Switzerland we call it a 'Grittibänz'). Fineliner with watercolour.

Pencil and watercolour.

The Call of Colour

I now understand why people used to say to me, first learn to draw, then worry about colour. I found it old-fashioned and schoolmasterish. Today I see the logic in it. It's like learning how to walk before you run. I'm including this here for you again in case you've been skipping through, as I did, and sometimes only find the important things at second glance.

Whether with longer pastel studies or coloured line drawings, something has changed completely for me since finding my new access to drawing. It feels good, but I can't find any meaningful words for it yet. Maybe that's actually a sign of seeing-thinking.

My intermediate conclusion from the process of learning and from many courses is this: courage is good, but it's much better when combined with step-by step learning and doing. When drawing things, I sometimes feel like I'm looking through them. Sounds weird. What I mean is that it's not always easy to find universally comprehensible words when talking about drawing. I hope that in other parts of the book I've at least halfway succeeded.

If you're already well underway with drawing, you'll have an easier time with colour. This, too, is no matter of luck or talent.

Clementine. Gently sketched in pencil, then colored with watercolour.

Bone pieces. Pencil drawing with watercolour.

Apple in pastel, blurred with fingers. One of my first attempts after black and white drawing in pencil. The apple, by the way, was not drawn according to a 'how to draw apples' guide. I actually did it on my own, by looking and adjusting again and again until it was consistent. Pastels are well-suited for this. They're neither too hard nor too dusty. It took about three or four hours — fortunately, all sense of time is generally lost while doing this.

Don't be afraid of blurring, trying things out, and intermediate stages! Above: from the right-hand 'apple', you could make a smaller one (continue with the left side, shrink the shape on the right with a light pastel) or a large one (continue going on the right side and finish the left). Below: I appreciate irregular fruit the most. These six apples, for instance, are from the same tree.

Watercolour. A world of its own. Most people use too <u>little</u> paint and way too <u>much</u> water in the brush. The best instructions I've found were from Charles Reid. His watercolour books are much sought-after and can occasionally be found in used book shops. He doesn't mince words when he says that if your drawing skills are weak, get them in order before trying watercolours. The main reason for this, in my opinion, is that without certainty in proportions, there is also little that can be done with watercolours.

Books – Further Motivation, Perhaps Also for You

» Standard works on learning and talent: *The Talent Code* by Daniel Coyle, 2009, and *Mindset: The New Psychology of Success* by Carol Dweck, 2007.

» The publisher 'Dover Art Library' offers cheap books on drawing starting from 10 euros. They're often cheaply printed (more like booklets), but still interesting to look at. They have booklets with drawings from Rembrandt, van Gogh, Michelangelo, Leonardo, Schiele, and many others, as well as collections like *150 Master Drawings*, interesting old handmade drawing books from the English-speaking world, and much more. I also find the drawings of Adolph Menzel, David Hopper, Horst Janssen, Andrew Wyeth, and John Singer Sargent inspiring.

» As an extended background in practical, foundational research on learning to draw for both beginnners and teachers, I recommend the 4th (final and comprehensive) edition of the most successful drawing book in the world: *Drawing on the Right Side of the Brain®* by Betty Edwards (2012). This book was originally intended as a textbook for a semester-length course in the late 1970s.

» For practical learning without a lot of theory, there is also the workbook that goes with it, about DIN A4* with ring binding (2nd revised edition), which contains around 40 exercises.

» *The Creative License* by Danny Gregory builds strongly on Betty Edwards' approach (as so many things do), but thereafter deals more with sketching in everyday life.

» Recommended: *The Natural Way to Draw* by Kimon Nicolaïdes (intensive learning programme).

» Useful for those already at an intermediate level are *Zeichnen in der Natur* ('Drawing in Nature') and *Zeichnen. Tipps für Kreative* ('Creative Drawing. 100 Tips to Expand your Talent', Hoaki Books, 2019) by Albrecht Rissler, as well as *Urban Watercolor Sketching: A Guide to Drawing, Painting, and Storytelling in Color* by Felix Scheinberger.

» If you want to go deeper into the topic of the duality of the brain, then you should consider *The Master and his Emissary: The Divided Brain and the Making of the Western World* by Iain McGilchrist. It's a profound but readable standard reference work – the result of decades of effort, with provocative theses, both eye-opening and exciting. Very thoroughly researched, with a bibliography as thick as a paperback. Highly recommended.

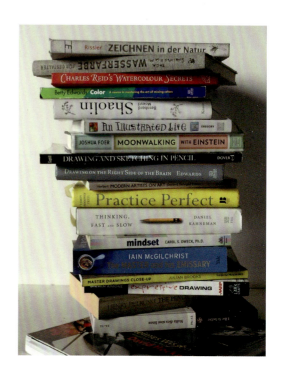

American letter-size paper (8 1/2 x 11 inches)

Again: If things aren't working out on your own, there is no shame in seeking support.

If you aren't making progress with drawing alone, seek competent help. <u>Remember</u>: only those who were able to figure it on their own as kids are generally considered to be talented. Learning (necessary for having) is not a sign of weakness. With drawing, it took me 30 years to accept this. Be smarter. Be faster.

What helped me, after years of depressing 'talent doubt' and non-drawing, were three courses in the US with Brian Bomeisler (Betty Edwards' son). I was able to do a lot with his extensive course experience and with his simple, determined focus on 'flipping the switch' and on the basics of drawing perception.

Courses using Betty Edwards' method can be found at www.drawright.com. Here you can also order the Plexiglas 'Picture Plane' and other learning materials as a set, complete with video.

In Switzerland (near Zurich), I offer a very similar course with my own unique twist. My classes are designed for people who also want to ex-perience what seeing can really be and how inspiring it is for other areas of life: private and professional, whether one's job is in a creative field or not. New perspectives are helpful in every facet of life. Information can be found at: www.stressfreizeichnen.com and david.koeder@gmail.com.

My course is also available in an independent study format, with individual feedback. You can learn and practise at home; feedback and support are available via e-mail, when needed, with demonstration films provided for better understanding.

Panoramic photo in the studio

Some Examples of What Can Happen in a Few Days When the Focus Is on Perception and 'Switching' to Visual Intelligence

These are before-and-after drawings from people who have immersed themselves in a coherent introduction to the component skills of drawing. The examples show the doors that can open if, for example, the fear of incorrect proportions is removed from the game. The 'after' drawings followed the 'before' drawings by only two to five days. These are smartphone photos from the course, so the photo quality is somewhat mediocre. My hope, however, is that the quality of the practise drawings makes up for it.

'When you're in a hurry, slow your pace.'

Adapted from the classical adage 'Festina lente'

This saying doesn't exactly fit in with the everyday logic in our culture. But it works wonderfully in learning to draw, even if it's hard to believe at first.

'If the doors of perception were cleansed, everything would appear to man as it is, infinite.'

William Blake

An intently observed banana. Matteo B., age 9.

Typical example of before-and-after effects for participants in the distance learning or studio course.

Tamer A.

Laura S.

Naomi K.

Bjorn G.

Kim G.

Beate K. from Norway.

Epilogue

If after reading this book you're more interested in drawing than you were before, it has served its purpose. If you now see drawing in a little different light, I'm happy. And if you've already had your first successes with the suggestions for learning, I'm even happier.

I specifically developed several of the exercises within the past two years to make it even easier and less stressful to get started – including for readers who, before this book, had every reason to consider themselves completely untalented.

I hope you've done some of the exercises and/or at least now know that a pathway to drawing is there for you when you're ready.

I'm not nearly as far along as I'd like to be – but remember, at the beginning of 2012 I couldn't even begin to do what you see in this book. I hope that gives you the push you need to get started, if you need one. I enjoy answering readers' questions, by the way, when time allows.

David Köder

Scurrilously sprouting potatoes. There is so much to see and to draw – both the mundane and the bizarre. Anything can be fun if you can overcome the stress of drawing through 'aha!' experiences, success, and some basic training. Or at least if you can tame it a bit. Enjoy!

When you really 'hit' a flowing line, it can be so much fun. Until that time, the more basic training you have, the more 'hits' you'll get. That's my conviction. Practicing without an introduction to the basics of perception seems to me in retrospect to be unnecessary torture for all involved.

'I awoke, only to see that the rest of the world is still asleep.'

Leonardo da Vinci

'Draw, Antonio; draw and don't waste time.'

Michelangelo

'Truly, art is embedded in nature.'

Albrecht Dürer

I hope you had some fun and that I was able to clarify a few misunderstandings regarding talent, learning, and drawing.

These drawings aren't scientific proof, but are another exciting hint that perception can actually be <u>awoken</u> with rather little effort. Without having done realistic drawing before, our daughter took my sketchbook during our holidays in 2013 and produced a dozen of these drawings without any help whatsoever. Starting with the portrait – in about 90 minutes in a busy restaurant. A full year earlier, she had very attentively and slowly done three upside-down drawings (see exercise on page 52), had done the exercise in blind drawing, and had drawn her hand on Plexiglas once. Other than that, nothing.

Drawing level of Naomi K. at age 12, without conventional 'practice'.

HOAKI

C/ Ausiàs March, 128
08013 Barcelona, Spain
T. 0034 935 952 283
F. 0034 932 654 883
info@hoaki.com
www.hoaki.com

Learn to See, Learn to Draw
The Definitive and Original Method for Picking Up Drawing Skills

ISBN: 978-84-17656-09-6
D.L.: B 23243-2019
Printed in Turkey

Copyright © 2018 by dpunkt.verlag Gmbh, Heidelberg, Germany
Title of the German original: *Dein Zeichentalent ist kein Fisch, 2 Auflage*
ISBN: 978-3-86490-636-7
Copyright © 2020 by Hoaki Books, S.L.
All rights reserved

English translation: Spencer Nelson
Proofreading: Barbara Lauer, copy editing: Friederike Daenecke, Zülpich,
layout and typesetting: just in print, Bonn, Germany, production:
Stefanie Weidner.